CONSTABLE

Pictures from the Exhibition

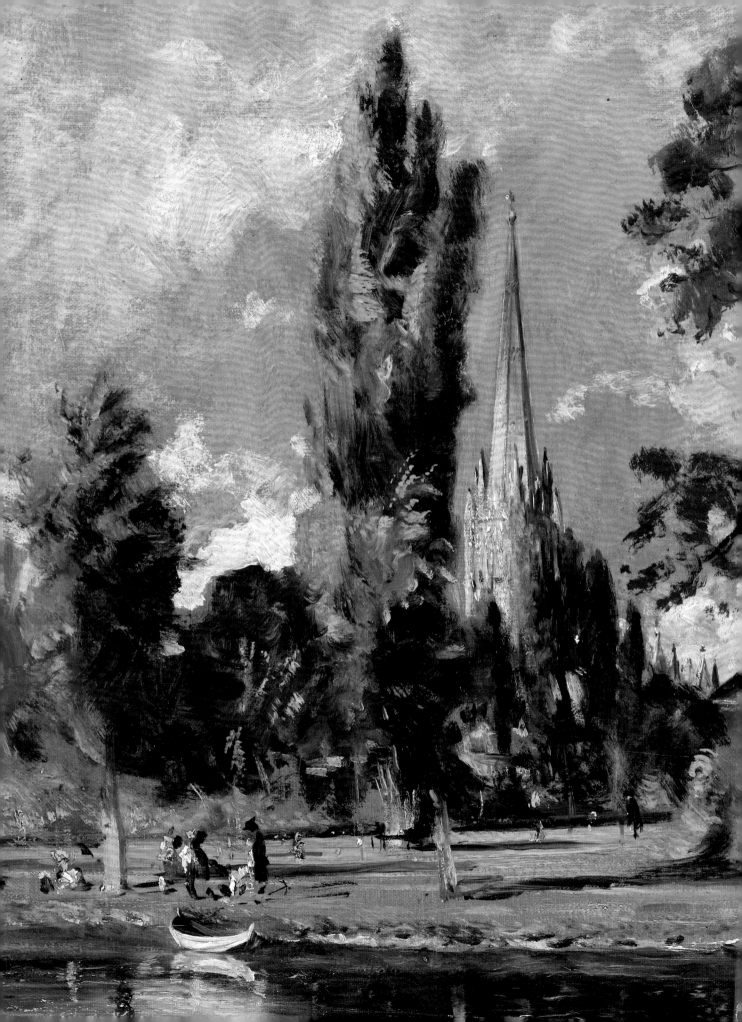

CONSTABLE

Pictures from the Exhibition

LESLIE PARRIS

Tate Gallery 1991

THE CONSTABLE EXHIBITION IS SPONSORED BY BARCLAYS BANK PLC

front cover
'The Wheatfield'
(detail of pl.24)

frontispiece
'Salisbury Cathedral and Leadenhall from the River Avon'
(detail of pl.45)

Measurements of illustrated works are given in millimetres
followed by inches in brackets; height before width

ISBN 1 85437 072 3

Published by order of the Trustees 1991
for the exhibition of 13 June – 15 September 1991
Copyright © 1991 The Tate Gallery. All rights reserved
Published by Tate Gallery Publications, Millbank, London SW1P 4RG
Typeset in Monophoto Ehrhardt by Servis Filmsetting, Manchester
Printed and bound in Great Britain by Balding + Mansell plc,
Wisbech, Cambridgeshire on 150gsm Parilux Matt

Contents

Sponsor's Foreword

'Constable Country' is an especially evocative phrase to all who know and love England and the English countryside. Barclays' roots in that part of the world are particularly deep. Our modern world of high finance and international banking shows a proper concern for all aspects of our environment, but especially for the countryside.

John Constable, surely Britain's best-loved painter, captured as no one else the essential spirit of the English landscape. Barclays is delighted to be able to sponsor this major exhibition of John Constable and to support the Tate Gallery. The Tate is not only an admirable centre of scholarship for British painting but is also a source of delight for all visitors both British and overseas. We hope as many as possible will benefit from this unique opportunity to share this experience themselves and to continue to enjoy it for many years through this excellent publication.

Sir John Quinton
Chairman, Barclays Bank PLC

Foreword

Unlike Turner, Constable made no provision for keeping his works together after his death. Through very generous gifts made in 1887–8 by his last surviving child, Isabel, large numbers of his paintings and drawings were distributed among the national collections in London, which also acquired notable examples from a variety of other sources. Many more works were dispersed in sales and these found new homes in private collections – some eventually in public collections – throughout the world. Even within London, it is difficult to form an overall view of Constable today without bringing his works together in a loan exhibition. We make no excuse therefore for mounting another major Constable display fifteen years after the bicentenary exhibition here in 1976. This new show, unlike the earlier one, focuses entirely on Constable's landscapes and it includes a high proportion of works that were either not known about in 1976 or were unavailable for loan then. It also approaches the artist in a different way. The breadth and originality of Constable's vision will, I believe, emerge more fully than ever before.

The organisers of the exhibition, Leslie Parris and Ian Fleming-Williams, have written a detailed catalogue. In order to reach as wide a public as possible, we have decided also to publish this short introduction and I am grateful to Leslie Parris for devising and writing it.

Our exhibition would not have been possible without the generous support of the many owners of Constable's works, both here in London and throughout the world. Full acknowledgment of their help and of the assistance we have received from other sources is made in the catalogue. A very special word of thanks goes to Barclays Bank for their sponsorship of the exhibition.

Nicholas Serota
Director

Introduction

This exhibition has been arranged in a way that is partly thematic and partly chronological. Some of the works are grouped together, irrespective of their precise date, to show the range of the artist's responses to particular subjects or places, while an overall chronological framework is designed to preserve a sense of his developing career. We hope in this way to bring out more completely than has been possible in previous exhibitions the variety of Constable's attitudes to nature and to the art of landscape.

The principal division of the show into 'The Suffolk Years' and 'The London Years' reflects the major re-orientation of Constable's life and work that took place on and soon after his marriage in 1816. Each part is subdivided. In 'The Suffolk Years' we look first at Constable in the year 1802, when he made his famous decision to become a 'natural painter', and then follow him through the three main geographic and thematic areas of his early work, moving from distant views of the Stour valley to the more intimate material he found at East Bergholt and Flatford. The next section, 'Paintings from Nature', is a more chronological treatment of the work of the years 1814–17, years that saw Constable's naturalism at its most literal. The second and larger part of the exhibition, 'The London Years', opens with two of the great set-pieces that Constable started painting when he moved permanently to London. The new material that he found during his long stays at Hampstead, Salisbury and Brighton is examined next before we move on to the large paintings of the later 1820s. Finally, the *English Landscape* mezzotints give us Constable's own overview of his work of the 1810s and 1820s and act as a prelude to the diverse productions of his final years.

In making this selection of pictures from the exhibition I have tried to combine some of the well-known works with a number of the recent discoveries that are a special feature of this 1991 show. Visitors will realise how much has had to be left out. In particular, Constable's drawings, which occupy two rooms of the exhibition, receive far less than their due in this short introduction. Everything is, however, reproduced and discussed in the full catalogue. I would like to thank its co-author, Ian Fleming-Williams, for letting me use here some of the material for which he was responsible in that volume.

Leslie Parris

THE SUFFOLK YEARS

Although Constable began lodging in London when he became an art student in 1799, he continued to regard his parents' house in East Bergholt, Suffolk as his home up to the time of his own marriage and more permanent move to London in 1816. Until then he spent a large part of each summer painting and drawing in Suffolk, driven by a desire to come to terms in as direct a way as possible with the scenes he had known since boyhood and which were becoming increasingly precious to him as he grew older. These scenes inspired him throughout life but it was only during his 'Suffolk years' that he was, and felt the need to be, in regular and close contact with them.

East Bergholt, Constable wrote in later life, is 'pleasantly situated in the most cultivated part of Suffolk, on a spot which overlooks the fertile valley of the Stour, which river separates that county on the south from Essex'. He fondly recalled the beauty of the surrounding countryside: 'its gentle declivities, its luxuriant meadow flats sprinkled with flocks and herds, its well cultivated uplands, its woods and rivers, with numerous scattered villages and churches, farms and picturesque cottages'. As a farmer but chiefly as a corn and coal merchant with his own mills and barges, his father, Golding, had his own interest in such scenes; Constable at first followed him into the family business. A growing realisation that he needed to deal with the landscape in a different way was encouraged by John Dunthorne, the village plumber, glazier and a keen amateur artist, by meetings with the influential collector and amateur painter Sir George Beaumont and by contact with a group of artists and antiquarians at Edmonton, including J.T. Smith and John Cranch. Constable was twenty-two before he entered the Royal Academy schools as a probationary student in 1799. By 1802, however, he had looked hard at the work of other landscape painters and had decided that something was missing: 'there is room enough for a natural painture', he told Dunthorne: 'The great vice of the present day is *bravura*, an attempt at something beyond the truth'. He resolved to 'make some laborious studies from nature' at Bergholt that summer, adding 'I shall endeavour to get a pure and unaffected representation of the scenes that may employ me'.

pl.1 'Dedham Vale: Morning'
(detail of pl.6)

The Valley

In pls.2–3 we see two of the studies Constable made as a result of his historic decision in 1802. Both are views of the Stour valley (or Dedham Vale as it is also known) from the surrounding hills and both were painted largely on the spot. 'Unaffected' these studies may be, but they are not artless. Although finding little to look up to in the work of his contemporaries, Constable had already formed a deep admiration for the

landscapes of earlier masters, especially Claude and Gainsborough. His technique of painting was indebted to both at this stage, while in deciding to paint the Suffolk countryside he was doing – but this time more directly – what the young Gainsborough, born in Sudbury, had done fifty years or so earlier. From Claude he took certain ideas of pictorial composition, balancing tall foreground trees against distant vistas; in the upright 'Dedham Vale' (pl.2) Constable adapted the design of a Claude he knew intimately, the 'Hagar and the Angel' owned by his early mentor Sir George Beaumont. This view of Dedham with the Stour estuary beyond remained a favourite subject of Constable's; his final realisation of it was the great 'Dedham Vale' of 1828 (pl.65). The other study shown here (pl.3) was a forerunner of his more panoramic views of the valley, such as we see in pls.6, 23 and 24. While a 'natural' painter could not admit into his landscapes the sort of biblical and mythological figures that Claude used, he could include, as Constable does here, a rustic figure in the manner of Gainsborough.

pl.3 'Dedham Vale', 1802, oil on canvas 343 × 427 (13½ × 16¹³⁄₁₆), *Yale Center for British Art, Paul Mellon Collection* (cat.no.4)

pl.4 'Dedham Vale', 1810, oil on
paper laid on board mounted on panel
154 × 260 (6$\frac{1}{16}$ × 10$\frac{1}{4}$), *Private
Collection, New York* (cat.no.10)

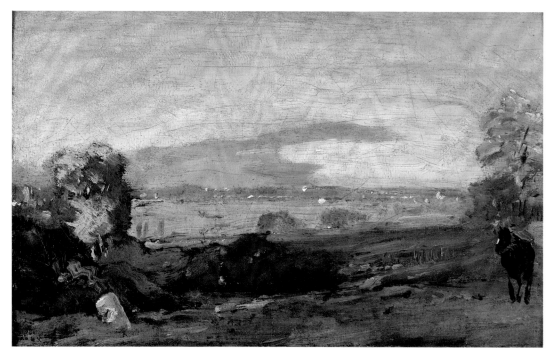

pl.5 'Dedham Vale', 1810, oil on
canvas laid on panel 170 × 218
(6$\frac{11}{16}$ × 8$\frac{9}{16}$), *Mr and Mrs David
Thomson* (cat.no.11)

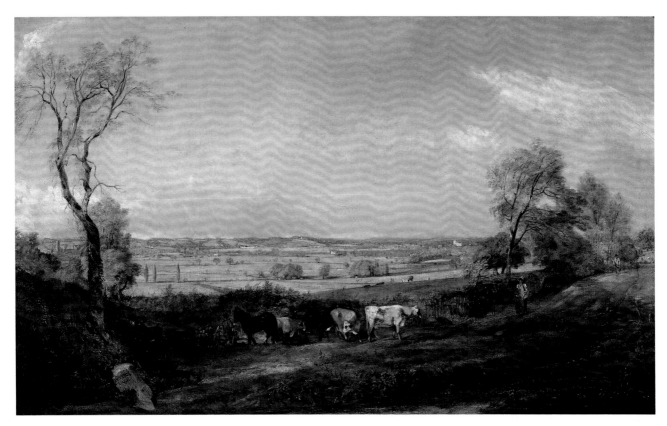

pl.6 'Dedham Vale: Morning', 1811,
exh.1811, oil on canvas 788 × 1295
(31 × 51), *W.H. Proby, Elton Hall*
(cat.no.14)

After the brave start he had made in 1802, Constable's progress was slow and
intermittent. In 1804 he was painting portraits of local farming families. In the
following two years drawing and watercolour painting took over from oils as his
chosen media. Through them, especially on a tour of the Lake District in 1806, he
learned how to describe landscape forms more convincingly. Around 1808 he took up
outdoor oil sketching and by 1810 had made it an indispensable tool for the prep-
aration of larger pictures.

'Dedham Vale: Morning' (pls.1, 6), exhibited in 1811, was his most ambitious
depiction so far of his native scenery, a work on which he staked his professional and,
since he was now contemplating marriage, his personal future. One of several oil
sketches and drawings made for it (pl.4) shows a setting sun and returning labourer,
suggesting that he originally thought of an evening view of the valley. Another (pl.5)
conveys the beauty of the scene as revealed by early morning light, with the floor of the
valley still blanketed in mist. In the final painting Constable focuses on a simple
episode that epitomises morning in the valley – a boy bringing up cattle from their
overnight pasture. At the right a man and a woman enter the valley on their way to
work. The Claudean composition and the stone inscribed, like some antique frag-
ment, 'DEDHAM VALE' add a further, Arcadian, dimension to the picture.

The Village

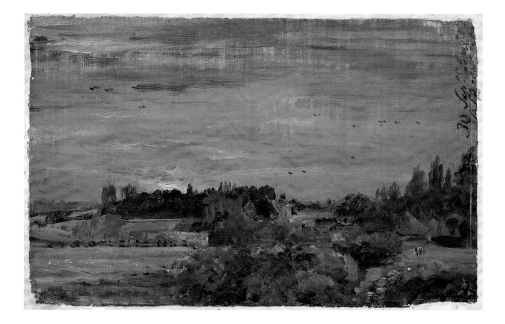

pl.7 'The Rectory from East Bergholt House', 1810, oil on canvas laid on panel 153 × 245 (6 × 9⅝), *John G. Johnson Collection, Philadelphia Museum of Art* (cat.no.23)

Although in his early years Constable frequently chose to paint on the hills overlooking the Stour valley, he also found material, more intimate in character, in the village itself. From the upper windows at the back of East Bergholt House he could look out over his father's fields towards the rectory with its distinctive background of trees. Precious to him because he associated these fields with his 'boyish days', the view acquired new meaning after he declared his love in 1809 for Maria Bicknell, then on a visit to her grandfather, Dr Rhudde, at the rectory. The early stages of their courtship were conducted in the same fields, 'those sweet feilds', as Constable called them in a letter to her, 'where we have passed so many happy hours together'. In 1810, when the oil sketch seen in pl.7 was made, the couple had not yet encountered the rector's opposition: perhaps appropriately, Constable painted the view at sunrise.

While pl.7 shows us the colourful and expressive oil sketching style Constable developed from 1810 onwards, the two views over the gardens of East Bergholt House that he painted in 1815 (pls.8–10) introduce us to a new phase in his work. From 1814 to 1816 he made what for its time was a unique attempt to produce finished pictures directly from nature. Sitting at upstairs windows of his father's house, he was able in this case to combine the best of both worlds, to paint from the motif in the security of a makeshift studio. Between them, the two canvases give a brilliantly detailed panorama of the view seen only partially in the earlier oil sketch, pl.7, but it is a panorama that is not quite continuous in either space or time because the two works were painted from different floors and at different stages of the summer. We might guess that they had a

pl.8 'Golding Constable's Kitchen Garden' (detail of pl.10)

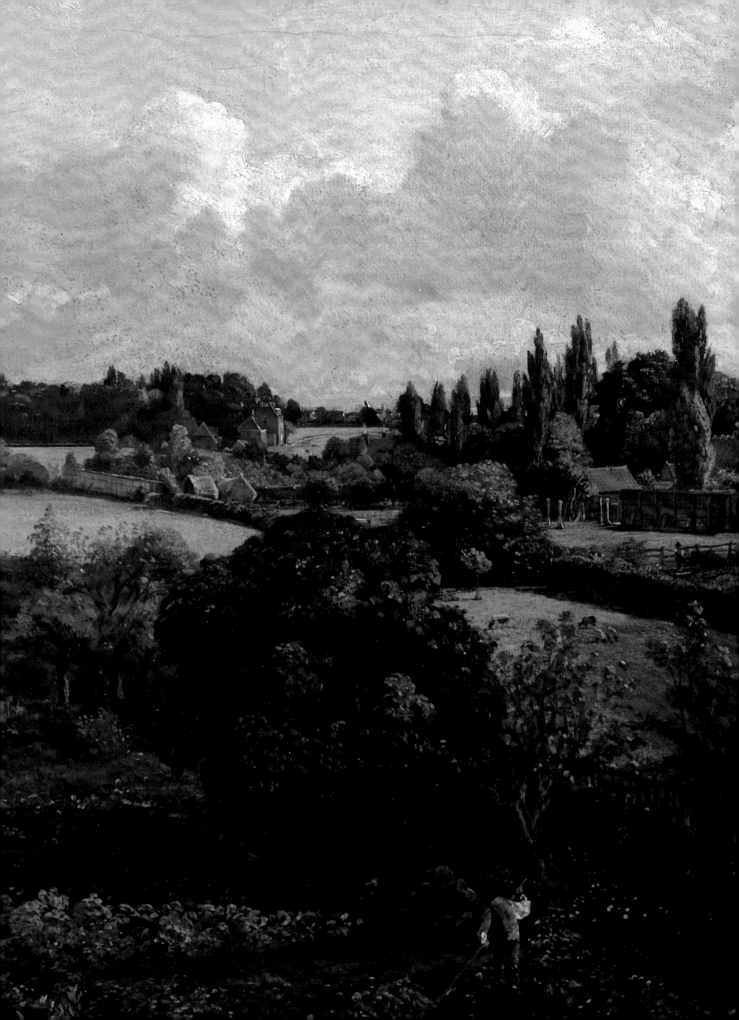

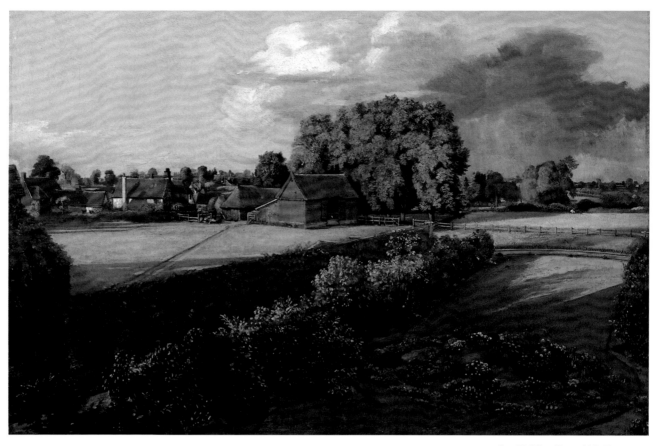

special meaning for Constable from the fact that he never exhibited or sold them. His
mother had died earlier in 1815 and his father's health was failing. The two paintings
seem to have been inspired by an impulse to memorialise his parents and to record
scenes that he knew he would not be able to enjoy much longer himself.

East Bergholt House lay on the wrong side of the village to give Constable views
over the Stour valley. He had a good friend, however, in Mrs Sarah Roberts, an elderly
widow who lived across the street at West Lodge. The meadows behind her house
became one of Constable's favourite painting grounds and from here, looking west-
wards over the valley, he frequently sketched sunsets (pl.11). While Constable
associated the fields behind East Bergholt House with Maria, old Mrs Roberts came to
associate her sunsets with him: 'she says she always thinks of you,' his mother told him
in 1809, 'at the setting sun, thro' her trees'.

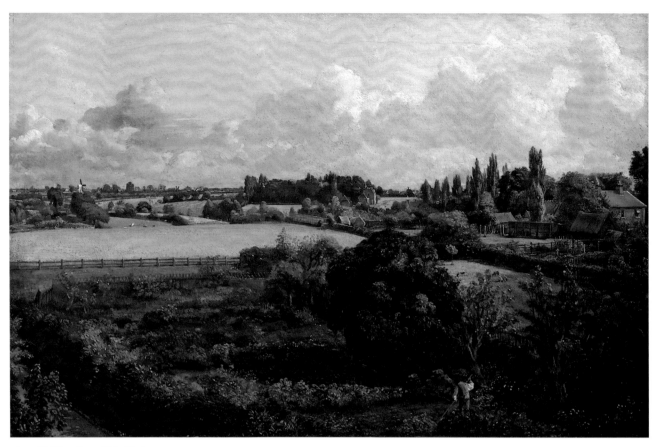

pl.10 'Golding Constable's Kitchen
Garden', 1815, oil on canvas
330 × 508 (13 × 20), *Ipswich Museums
and Galleries, Ipswich Borough Council*
(cat.no.26)

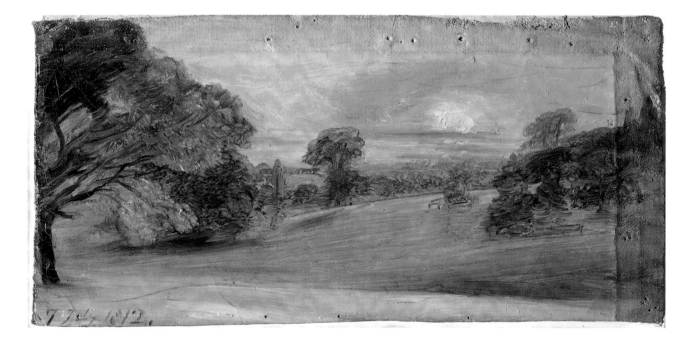

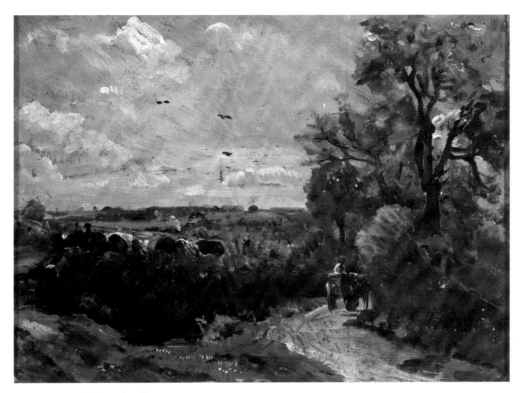

pl.12 'A Cart on the Lane from East
Bergholt to Flatford', 1811, oil on paper
laid on canvas 153 × 212 (6 × 8⅜), *Board
of Trustees of the Victoria and Albert
Museum, London* (cat.no.41)

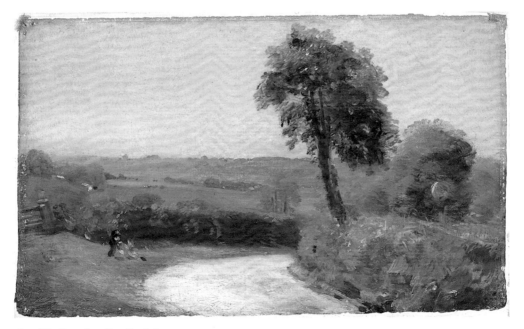

pl.13 'The Lane from East Bergholt
to Flatford', 1812, oil on paper laid on
card 165 × 280 (6½ × 11), *Museo
Lázaro Galdiano, Madrid* (cat.no.43)

Constable found other subjects in the lanes and fields around the village. He was out many times on the lane from Bergholt to Flatford, lying in wait for suitable figures to appear or supplying them himself. In the sketch seen in pl.12 a cart and horse, its harness fringed with crimson, are being driven up to Bergholt; smoke rises in the valley, perhaps from Flatford mill-house. In a more restrained sketch of the same lane made the following year (pl.13) a solitary figure, possibly Constable's friend Dunthorne, rests by the roadside. But in few of his works are figures so much the centre of interest as they are in the large study of men threshing or flailing turnip-heads to obtain seed (pl.14). This job was done in the fields to avoid the risk of losing the seed from the dried heads when they were moved. Rarely, however, did such sketches provide the material for larger paintings. For these he had to turn to the river Stour itself.

pl.14 'Flailing Turnip-heads', *c*.1812–15, oil on canvas 350 × 442 (13¾ × 17⅜), *Private Collection, New York* (cat.no.38)

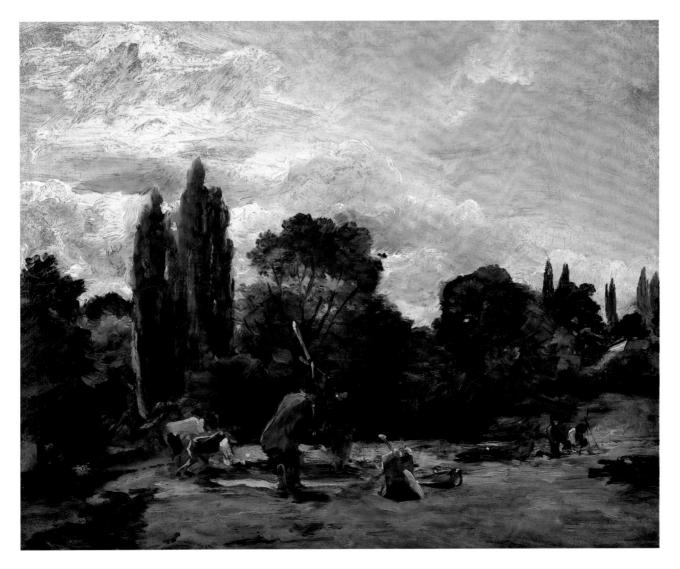

The River

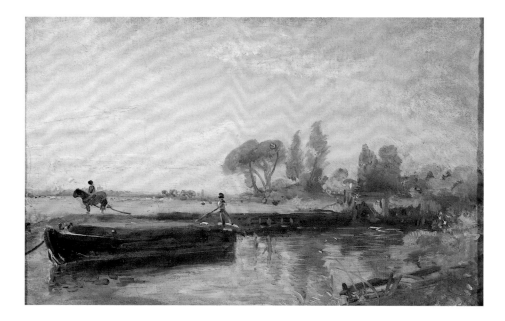

pl.15 'A Barge below Flatford Lock', ?1810, oil on (? paper laid on) canvas 197 × 324 (7¾ × 12¾), *Paul Mellon Collection, Upperville, Virginia* (cat.no.49)

The Constable family business – run by Golding until his death in 1816 and then by Constable's younger brother Abram – was centred on Flatford, down in the valley a mile or so from East Bergholt. Here on the canalised Stour they had their watermill for grinding corn and a dry dock for building the barges needed to transport grain to Mistley for onward shipment to London; returning barges brought coal and other London cargoes upstream. Golding also had a watermill further upstream at Dedham. Because of his interest and influence in these matters he was appointed one of Commissioners of the Stour Navigation, responsible for the upkeep of the canalised river, its locks and tow-paths.

The passage up and down the river of the horse-drawn barges (pl.15), which at Flatford had to negotiate both a lock and a footbridge, made a deep impression on Constable as a child. When he became an artist, it was perhaps inevitable that he should eventually focus on such scenes and make them the subjects of his paintings. 'I associate my "careless boyhood" to all that lies on the banks of the *Stour*', he wrote in 1821, 'They made me a painter'. Wherever he found himself in later life, he sought out rivers, canals and mills: 'the sound of water escaping from Mill dams . . . Old rotten banks, slimy posts . . . I love such things'.

pl.16 'Flatford Mill from the Lock' (detail of pl.19)

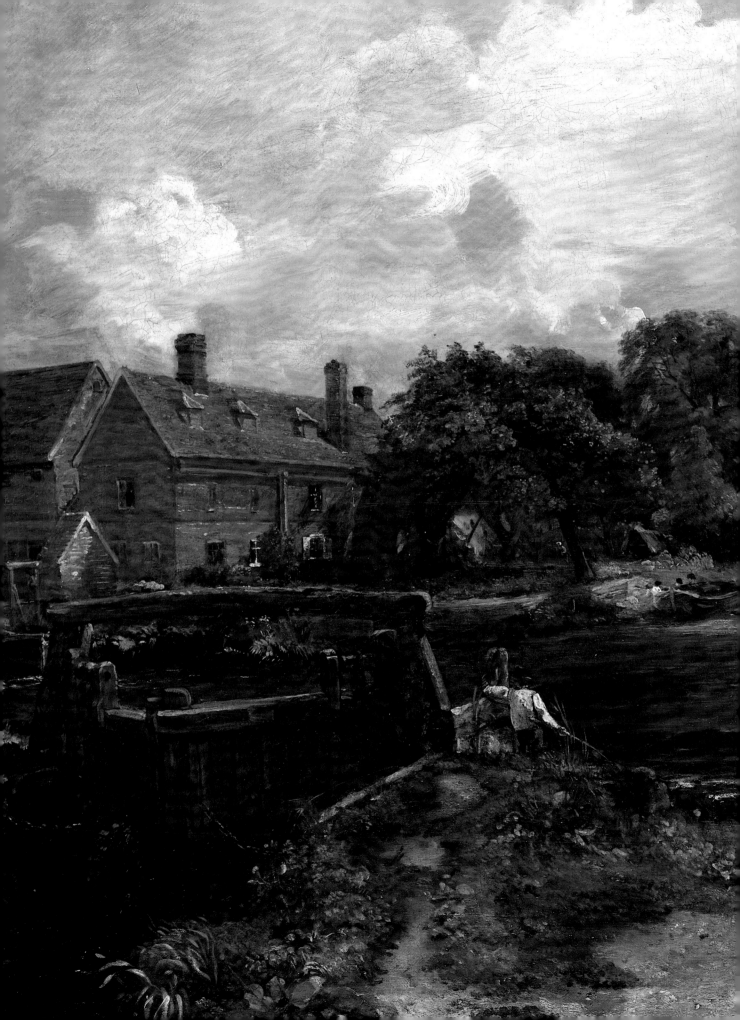

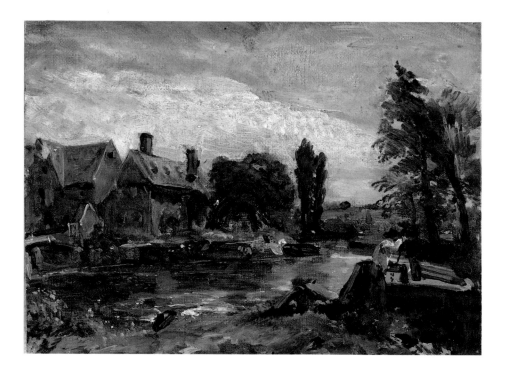

pl.17 'Flatford Mill from the Lock',
?1811, oil on canvas laid on board
152 × 212 (6 × 8⅜), *Mr and Mrs David
Thomson* (cat.no.52)

pl.18 'Flatford Mill from the Lock',
?1811, oil on canvas 245 × 295
(9⅝ × 11⅝), *Board of Trustees of the
Victoria and Albert Museum, London*
(cat.no.53)

With only two exceptions Constable exhibited a major picture of a river Stour subject at the Royal Academy every year from 1812 to 1825. The first of these, 'Flatford Mill from the Lock' (pls.16, 19), was painted after an intensive round of oil sketching at the site in 1810 and 1811 during which he examined different viewpoints, including one that placed the lock at the right of the composition (pl.17). The study seen in pl.18 shows the composition he finally settled on, with the river now firmly at the centre of things. A conspicuous difference, however, between the various sketches and the painting Constable exhibited at the Academy in 1812 (pl.19) is the exclusion of the man engaged in opening the lock. Traces of his red jacket can still be seen on the surface of the picture. In his place Constable introduced a boy with a fishing rod and gave him a companion at the right-hand side. Young anglers frequently appear in his subsequent work, from 'Boys Fishing' exhibited in 1813, to his final painting, 'Arundel Mill and Castle' (pl.81). The man at the lock was not forgotten, however. Constable took him up again in his 1817–20 paintings of Dedham lock (pl.55) and then gave him a commanding role in the large lock paintings of the 1820s (pls.54, 56).

pl.19 'Flatford Mill from the Lock', 1811–12, exh.1812, oil on canvas 635 × 902 (25 × 35½), *Mr and Mrs David Thomson* (cat.no.54)

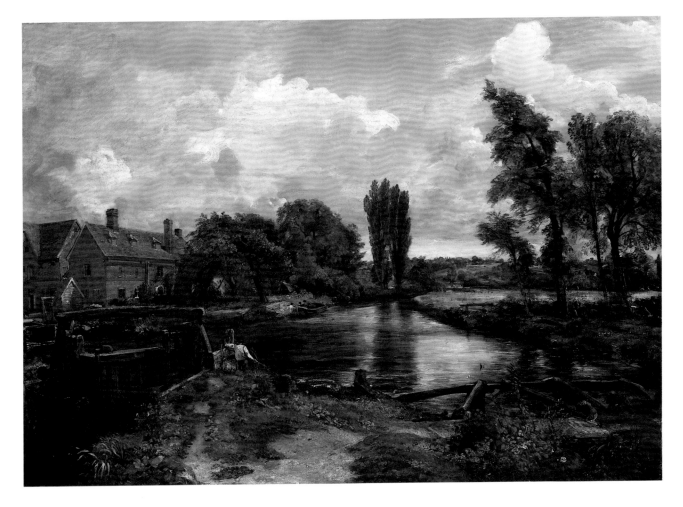

pl.20 'Willy Lott's House', *?c*.1811,
oil on paper 241 × 181 (9½ × 7⅛),
*Board of Trustees of the Victoria and
Albert Museum, London* (cat.no.58)

Constable made numerous studies from the back of Flatford mill, looking across the
mill stream to the house of the farmer Willy Lott. Something of a stick-in-the-mud,
Lott was reputed to have spent only four days away from home in eighty years (forced
to seek work in the outside world, another local character crossed the river into Essex
crying 'Good bye old England perhaps I may never see you any more') but this fierce
attachment to his native place may have been what Constable liked about him. Pl.20
shows one of several sketches that the artist later referred to when painting 'The Hay-
Wain' (pl.38). Constable's rapid notation of the dog is typical of the beautiful economy
of his oil sketching style: half-a-dozen strokes for the dog, one for its shadow; and
movement suggested by the slight disjuncture of the two.

The artist also painted Willy Lott's house from other angles. For the picture he
exhibited in 1814 as 'The Ferry' (pl.21) he took a viewpoint roughly at right-angles to
the one used for the oil sketch seen in pl.20. He was now looking from the south bank of

the Stour through a cutting that connected the mill water with its river. He first studied this view in detail in a large pencil drawing made about 1812–13 and it formed the subject of one of his very last paintings, 'The Valley Farm' of 1835. In 1814 he still had to solve the problem, when painting large works like this, of combining a strong design with the right amount of detail; his correspondence shows that he was well aware of the difficulty. He also appears to have felt that his exhibition pictures did not yet fully convey the sensations – of light and colour especially – that he experienced in the face of nature, sensations so well suggested in the oil sketches. In retrospect the answer may seem obvious: he would try to make finished pictures directly from nature.

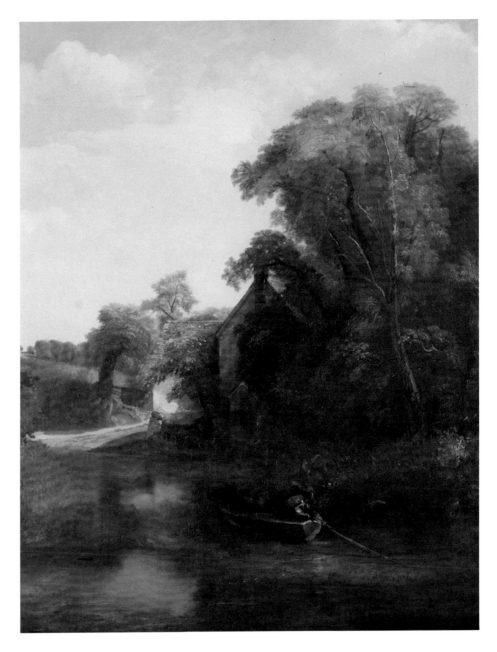

pl.21 'The Ferry', 1814, exh.1814, oil on canvas 1257 × 1003 (49½ × 39½), *Private Collection* (cat.no.65)

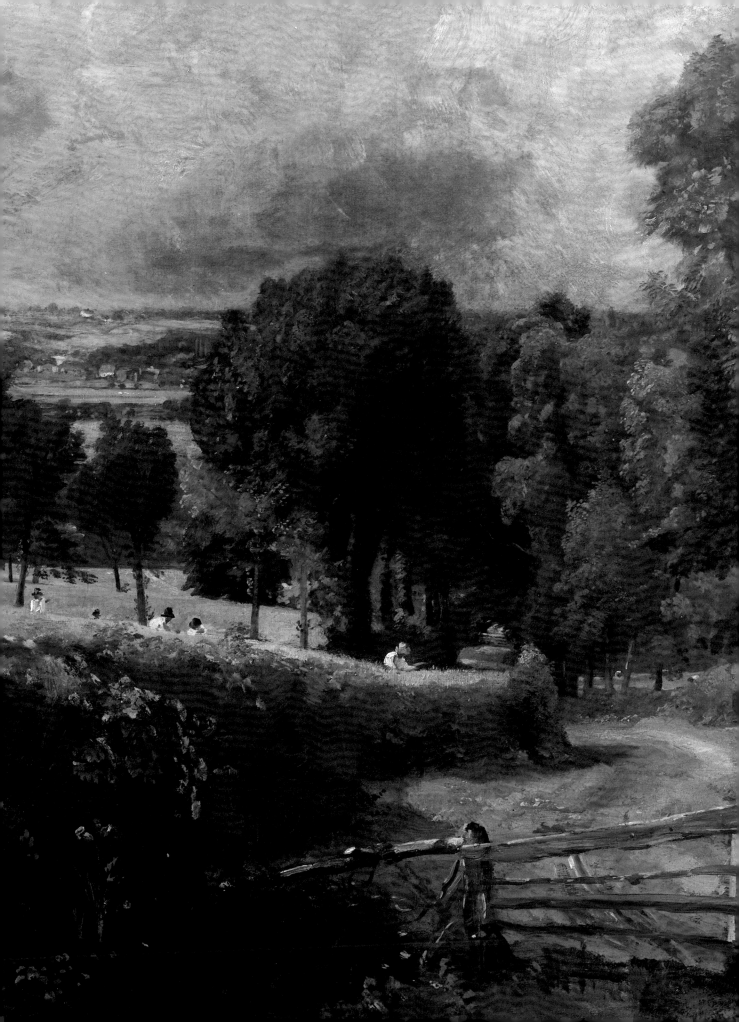

Paintings from Nature

Until 1814 Constable prepared his exhibition pictures in the studio, working from oil sketches and drawings. Feeling dissatisfied with the paintings he intended to exhibit that year, he told John Dunthorne that he was 'determined to finish a small picture on the spot for every one I intend to make in future . . . this I have always talked about but never yet done – I think however my mind is more settled and determined than ever on this point'. This was as important a decision as the one he had announced to Dunthorne twelve years earlier. Then he had talked of making 'laborious studies from nature', now it was to be small finished pictures, apparently to serve as the basis for larger ones that he would paint in the studio. In the event, later in 1814, he adopted the still more ambitious course of painting medium-sized exhibition pictures largely on the spot.

Constable made the most of the exceptionally fine summer and autumn that year and was able to report to Maria Bicknell in September: 'This charming season as you will guess occupies me entirely in the feilds and I beleive I have made some landscapes that are better than is usual with me'. In the mornings he worked on 'The Stour Valley and Dedham Village' (pls.23, 25), in the afternoons on 'Boat-Building', which shows a barge under construction in his father's dry dock at Flatford; both were exhibited at the Academy in 1815. The former picture was commissioned as a wedding gift for a local bride, Philadelphia Godfrey, and presents a panorama of the Stour valley from just outside the grounds of her father's house, Old Hall, East Bergholt. The men in the foreground are digging out manure from a dunghill to be ploughed into the fields; their dog directs our attention to the ploughman who is completing the process.

The summer of the following year, 1815 (when he also painted the two views over his father's gardens, pls.9–10), was again 'uncommonly fine' according to Constable. 'I live almost wholly in the feilds', he told Maria, 'and see nobody but the harvest men'. The picture he was working on, 'The Wheatfield' (pls.24, 26 and cover), shows the same field as the one in the foreground of the 1814 painting, pl.23. The ploughing underway in that picture was for the sowing of the wheat that we now see being harvested. At the side of the field a woman and two girls glean what the reapers leave, while in the foreground a boy and his dog – the same alert dog as before – survey the sea of wheat that remains.

pl.22 'Fen Lane, East Bergholt'
(detail of pl.34)

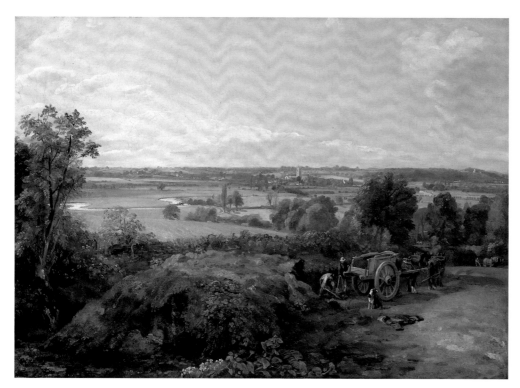

pl.23 'The Stour Valley and Dedham Village',
1814–15, exh.1815, oil on canvas 553 × 781
(21¼ × 30¾), *Museum of Fine Arts, Boston,
Warren Collection* (cat.no.74)

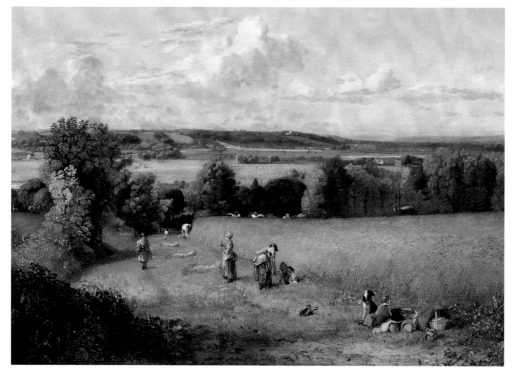

pl.24 'The Wheatfield', 1815–16, exh.1816,
oil on canvas 537 × 772 (21⅛ × 30⅜),
Private Collection (cat.no.76)

pl.25 'The Stour Valley and Dedham
Village' (detail of pl.23)

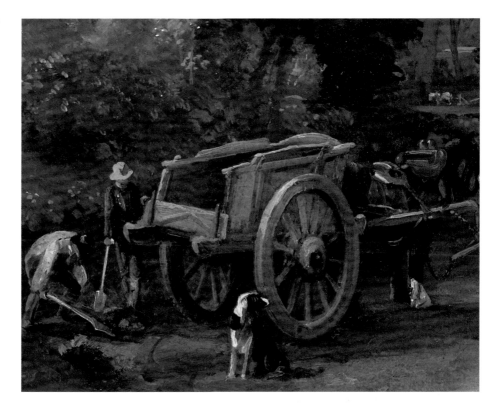

pl.26 'The Wheatfield'
(detail of pl.24)

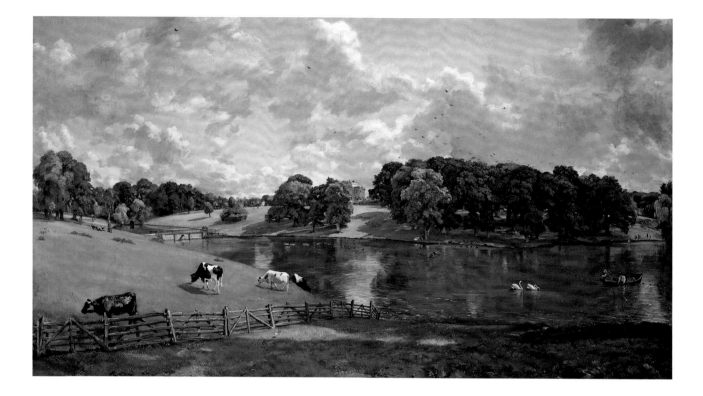

During his long courtship of Maria Bicknell, Constable encountered many difficulties, a principal one being her grandfather Dr Rhudde's objection to their marriage. In 1816 they decided to go ahead, whatever the social and financial consequences (Maria had been thought likely to inherit a large sum from Rhudde). Constable spent his last bachelor summer as usual, painting in Suffolk. The chief work on hand this year was the large 'Flatford Mill', pl.31, but he found time to fulfil a commission from Major-General and Mrs Slater-Rebow of Wivenhoe Park near Colchester for two pictures, one showing their house across the lake (pl.27). The Slater-Rebows knew the couple's situation and were determined, Constable told Maria, 'to be of some service' to them. Working at high concentration – 'I live in the park and Mrs Rebow says I am very unsociable' – he managed to complete all the outdoor work on the picture in about a week, despite a request to extend the composition (by stitching on extra strips of canvas) so that the family's deer-house could be accommodated. The painting ended up as one of Constable's widest panoramas, which (as in nature) compels the viewer to turn his head to take in all that it encompasses – from the daughter of the house riding out in her donkey cart at the left to the men pulling on their fishing line on the far bank at the right. Although Constable once declared 'a gentleman's park – is my aversion', we may be thankful that in this case he was thoroughly seduced by the beauty of the scene.

pl.27 'Wivenhoe Park, Essex', 1816, exh.1817, oil on canvas 561 × 1012 (22⅛ × 39⅞), *National Gallery of Art, Washington, Widener Collection* (cat.no.79)

The Constables were married by the Revd John Fisher at St Martin's-in-the-Fields on 2 October 1816 and spent most of their honeymoon with him and his wife at their vicarage at Osmington near the Dorset coast (pl.29). Fisher, nephew of Constable's early patron the Bishop of Salisbury, was Constable's closest friend and one of the few people who seem to have understood what he was trying to do. An amateur artist himself, Fisher provided painting materials on the honeymoon as well as on Constable's visits to him at Salisbury and he supported him in many other ways, not least by buying his first two six-foot canvases (see p.41).

It was during his stay at Osmington that Constable began painting beach scenes; such brilliant sketches as the one we see in pl.30 were forerunners of the large number he later painted at Brighton. He also worked high up on the Downs. In 'Osmington and Weymouth Bays' (pl.28) we look from near Osmington village down to a surf-fringed Redcliff Point, separating the two bays, and beyond to Portland Island and Weymouth. Constable describes the undulations of the downland and the perspective of the sea with total assurance, as though long familiar with what Fisher called this 'wonderfully wild & sublime' country.

pl.28 'Osmington and Weymouth Bays', 1816, oil on canvas 560 × 773 (22¹⁄₁₆ × 30⁷⁄₁₆), *Museum of Fine Arts, Boston, Bequest of Mr and Mrs William Caleb Loring* (cat.no.83)

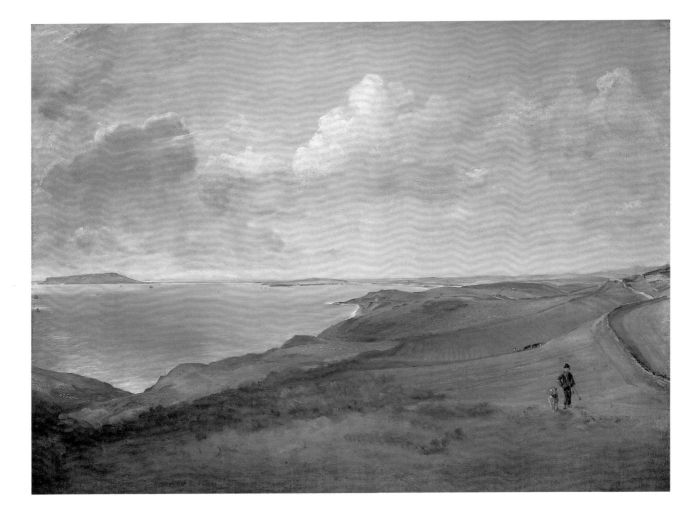

pl.29 'Osmington Village', 1816, oil on canvas 257 × 305 (10⅛ × 12), *Paul Mellon Collection, Upperville, Virginia* (cat.no.80)

pl.30 'Osmington Mills', 1816, oil on canvas 241 × 324 (9½ × 12¾), *Mr and Mrs Richard M. Thune* (cat.no.81)

The largest exhibition canvas that Constable worked on outdoors, 'Flatford Mill' (pl.31) was begun in the summer of 1816, a few months before his marriage. After showing it at the Academy in 1817 he repainted the sky and parts of the trees at the right. The difficulties he seems to have experienced in working on such a large scale outdoors probably contributed to the change in his methods that followed his move to London. Although he was to spend one more summer painting in the area, the picture is in many ways Constable's valediction to his Suffolk years, a fond farewell on the eve of marriage to the 'careless boyhood' he said he had enjoyed on the banks of the Stour. Boys are much in evidence: the most prominent one astride a tow-horse watches another managing a rope (the barges have been disconnected so that they can be poled under Flatford bridge), while young anglers occupy the tow-path and hang around the lock. As if to point up their 'carelessness', Constable adds in the field at the right the bent figure of a mower, shouldering his scythe like Father Time (pl.32). A similar figure appears in a drawing made the following year (pl.33).

pl.31 'Flatford Mill ("Scene on a Navigable River")', 1816–17, exh.1817, oil on canvas 1017 × 1270 (40 × 50), *Tate Gallery* (cat.no.89)

pl.32 'Flatford Mill ("Scene on a
Navigable River")' (detail of pl.31)

pl.33 'A Reaper, East Bergholt', 1817,
pencil on wove paper 115×186 ($4\frac{9}{16} \times 7\frac{5}{16}$),
*Board of Trustees of the Victoria and
Albert Museum, London* (cat.no.276)

In the summer of 1817 Constable and Maria spent what was to be their last long holiday in Suffolk. Maria, perhaps oddly, never returned, her husband only occasionally and on family business. Constable appears to have sensed that this would be his last chance to paint extensively from his native scenery. Several unfinished canvases, including 'Fen Lane' (pls.22, 34), have recently been associated with the 1817 visit and they suggest that he was intent on collecting as much material as possible, taking open-air pictures just far enough for them to be completed later in his London studio. In fact, they remained unfinished, his ideas about landscape painting having changed in the meantime. As a boy Constable used Fen Lane to get to school at Dedham. It features in several of his paintings, including the 1811 'Dedham Vale: Morning' (pl.6), where a cowherd is shown closing the gate that we see so carefully described in this 1817 picture. A gang of reapers, still standing waist-high in wheat, has begun to harvest the field on the left. The lane itself – crossed by shadows as it makes its uneven descent to the white gate down in the valley – is one of Constable's happiest pieces of observation.

pl.34 'Fen Lane, East Bergholt', ?1817, oil on canvas 692 × 925 (27¼ × 36⁷⁄₁₆), *Private Collection* (cat.no.91)

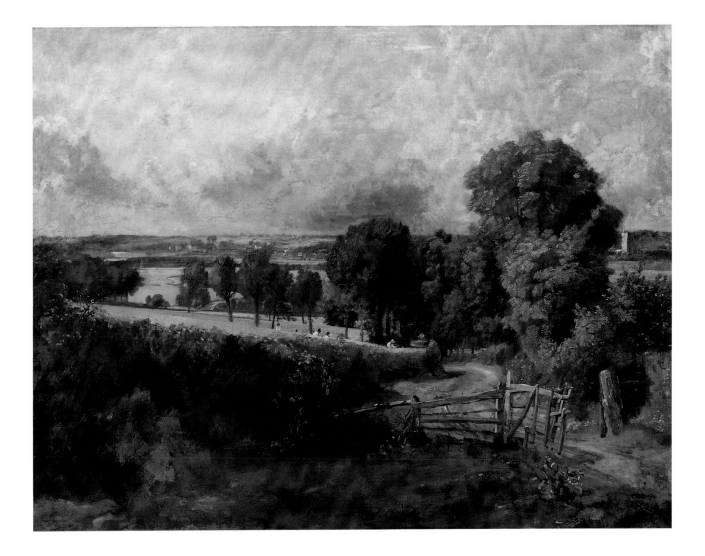

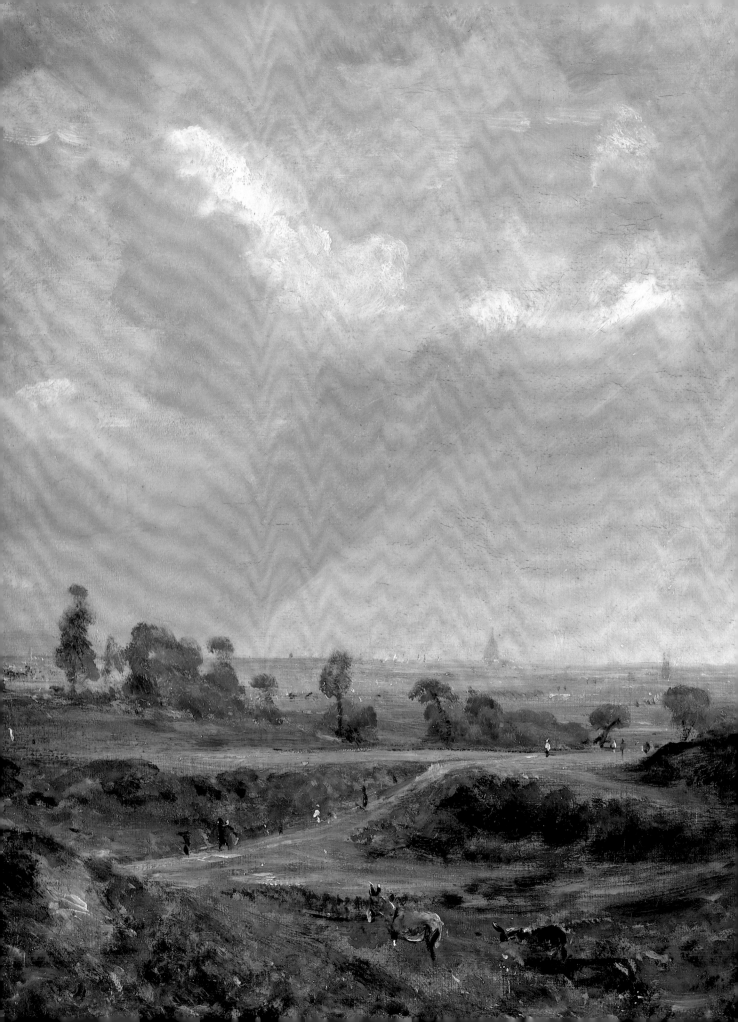

THE LONDON YEARS

Living first in the artist's bachelor lodgings in Charlotte Street, the newly married Constables moved to Keppel Street near the British Museum in 1817 and then in 1822 took over a more spacious house in Charlotte Street which had become vacant on the death of Constable's old friend and professional adviser Joseph Farington RA. This remained their – and their growing family's – home until 1827, when they took a lease on a house at Hampstead. From 1819 Constable had engaged summer lodgings at Hampstead for the sake of Maria's health and it was this same concern that led them to make long visits to Brighton from 1824 onwards. At Hampstead and Brighton, and on further visits to the Fishers at Salisbury, Constable found new subject matter for his art.

Suffolk was never forgotten, however. The mass of drawings, oil sketches and paintings that Constable had made there from his earliest years up to 1817 were the source for the most important of his later canvases. With this store of material to hand, working directly from his native scenes may have seemed no longer necessary and it would certainly have been impractical on the six-foot canvases he adopted in 1818. But Constable appears no longer to have actually wanted to work on Suffolk subjects in this direct way. While he continued to make oil sketches and small to medium-sized paintings outdoors in other parts of the country, he began treating his most familiar material in a new way, projecting it on a larger and grander scale that necessarily involved distancing himself from his original source.

'The White Horse' (Frick Collection, New York), exhibited in 1819, was the first in a series of six-foot paintings that represented Constable's new bid for recognition both of the importance of his subject matter (rural scenery being not much valued in the traditional academic hierarchy) and of himself as an artist. A lifelong and highly discriminating student of the old masters, in the early 1820s he redoubled his attention to Claude, the Poussins, Rubens and others, seeking to match their achievements on his own terms. Imagination and invention played an increasing role in the process and he was forced to adopt new studio practices to achieve his ends. The six-foot paintings were preceded or paralleled by full-size studio sketches – themselves unprecedented in the history of art – in which he tried to impose unity on his diverse source material and articulate the grand designs he now had in mind.

pl.35 'Hampstead Heath with London in the Distance' (detail of pl.43)

Early Set-Pieces

The first six of the six-foot canvases that Constable began exhibiting in 1819 were of scenes on the river Stour. To begin with he chose subjects that he had not made much of before: an unusual view of Willy Lott's house for 'The White Horse', for 'Stratford Mill' (pl.36) a setting that lay outside his normal territory altogether. Only with 'The Hay-Wain' (pl.38) did he face up to the problem of recasting his most familiar material on this ambitious new scale.

The idea for 'Stratford Mill', the second of the series, came from a small oil sketch Constable made in 1811, showing anglers beside the watermill at Stratford St Mary. He decided to develop this, through a quarter-size and then a full-size sketch, by extending the landscape on the right so that the river itself became the centre of interest. The anglers now only set the scene, inviting us to explore beyond – to trace, for example, the succession of pools and shafts of sunlight, of deep shades and

pl.36 'Stratford Mill', 1819–20, exh.1820, oil on canvas 1270 × 1829 (50 × 72), *Trustees of the National Gallery, London* (cat.no.100)

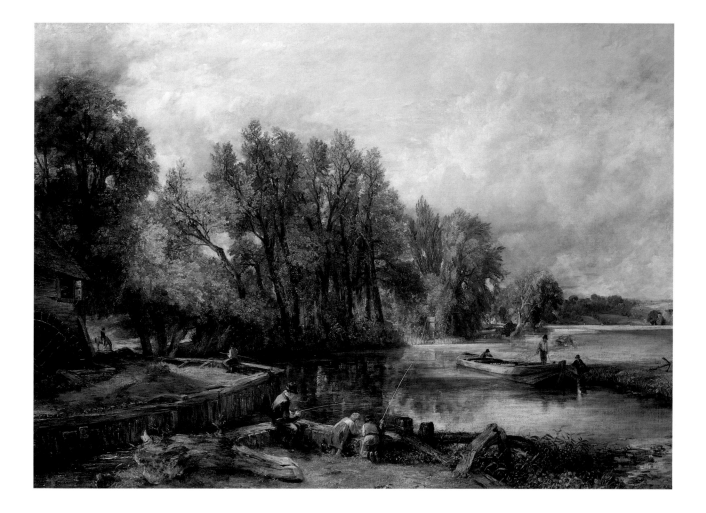

pl.37 'Stratford Mill'
(detail of pl.36)

glancing shadows, that articulate the middle distance, or to linger by that mysterious sunlit gate at the water's edge. We can get some idea of how Constable's methods of picture-making were changing by looking back to the 1817 'Flatford Mill' (pl.31). Less boldly organised in terms of chiaroscuro, the earlier picture is also a more enclosed and intimate work, lacking the long vistas that are opened up here. Emphasis is placed on things close to the viewer's eye, the tall trees at the right, for instance; in 'Stratford Mill' the principal trees gain in grandeur by being set well back. As yet, however, Constable had not worked out the sort of central figurative incident that his later 'six-footers' were to have.

'The White Horse' and 'Stratford Mill' did much to advance Constable's reputation. Following the exhibition of the former, which was said to be 'too large to remain unnoticed', he was at long last elected an Associate of the Royal Academy. But sales were another matter: his friend Fisher bought both pictures when they failed to attract any other buyers.

In 'The Hay-Wain' (pl.38), the third of his six-foot canvases, Constable returned to a subject close to his heart and one which he had often painted in the past, Willy Lott's house seen from behind Flatford mill. But the house was no longer his main focus, as it had been in the oil sketches from which the picture was developed, for example the one seen in pl.20. As with 'Stratford Mill', Constable expanded his original idea by extending the composition towards the right, opening up a vista, this time of hayfields in which mowers are at work. Unlike 'Stratford Mill', however, with its spread of figures, 'The Hay-Wain' has a central 'incident', the passage of the hay-wain itself. Having delivered its load, the cart is about to return through the cut on the right that leads to the main river, which it will cross by the 'flat ford' that gives the place its name. In the fields on the far side a second hay-wain is being loaded to take its place. The dog seen running along the shore in the early sketch (pl.20) is drawn into this story, watching the cart move off while the boy in it gesticulates at him. 'The Hay-Wain' was one of several paintings bought from Constable by the French dealer Arrowsmith. It created a sensation when shown at the Paris Salon in 1824 and particularly impressed Delacroix, who thirty years later described Constable as 'the father' of modern French landscape painting.

pl.38 'The Hay-Wain', 1820–1, exh.1821, oil on canvas 1305 × 1855 (51¼ × 73), *Trustees of the National Gallery, London* (cat.no.101)

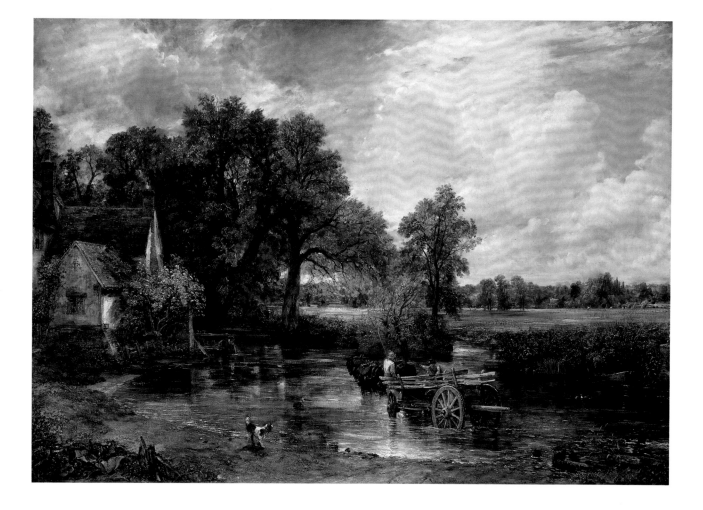

Hampstead

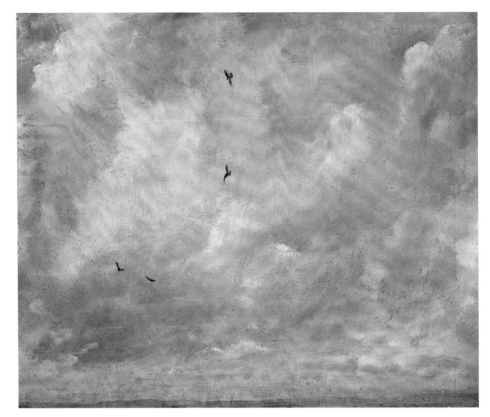

pl.39 'Cloud Study with Birds', 1821, oil on paper laid on board 255 × 305 (9⅞ × 12), *Yale Center for British Art, Paul Mellon Collection* (cat.no.121)

From 1819 to 1826 the Constables rented a house at Hampstead every summer except that of 1824. In 1827 they moved there more permanently, leasing a house in Well Walk and letting part of their own in Charlotte Street. Announcing this last arrangement to Fisher, Constable boasted that he was now 'three miles from door to door – can have a message in an hour – & I can get always away from idle callers – and above all see nature – & unite a town & country life'. The original reason for the Constable family's summer migrations was Maria's health, already showing symptoms of the tuberculosis from which she was to die. Constable joined her and the children as often as he could and soon found much to interest him at Hampstead. He began oil sketching again with a fervour not seen since his earlier Suffolk years, directing his attention especially to the sky, the most conspicuous feature of this upland landscape. While he was by no means the first artist to make oil studies of cloud formations, those he painted at Hampstead in 1821 and 1822 are unique in their quantity, in their understanding of the structure and movement of clouds and in their pictorial effectiveness. Within two years Constable painted up to a hundred studies of the kind seen in pl.39, as well as many more in which landscape and sky are studied together, as in

pl.40. Because many of the studies are dated to the hour, we can see how intensely he applied himself to the business, painting skies for several days on end and frequently in rapid succession. Each took about an hour. As well as dating them, Constable usually inscribed some comment on the weather. 'Sky Study with Birds' (pl.39) is annotated 'Sep. 28 1821 Noon – looking North West windy from the S.W. large bright clouds flying rather fast very stormy night followed'. References to preceding or following states of weather show him attempting to understand what he painted in terms of ongoing natural processes. His art in general shows a growing awareness from this time on of nature's animation.

Many of Constable's Hampstead oil sketches are of views westwards towards Harrow but few of them include such prominent figures as the family group seen enjoying the prospect in the example reproduced here (pls.40–1). The inscription on the back tells us that it was painted on 31 October 1821. 'The last day of Octr was indeed lovely', Constable wrote to Fisher, 'so much so that I could not paint for looking – my wife was with me all the middle of the day on the beautifull heath. I made two evening effects'.

pl.40 'Hampstead Heath, Looking towards Harrow', 1821, oil on paper laid on canvas 260 × 325 (10¼ × 12¾), *Yale Center for British Art, Paul Mellon Collection* (cat.no.110)

pl.41 'Hampstead Heath, Looking towards Harrow' (detail of pl.40)

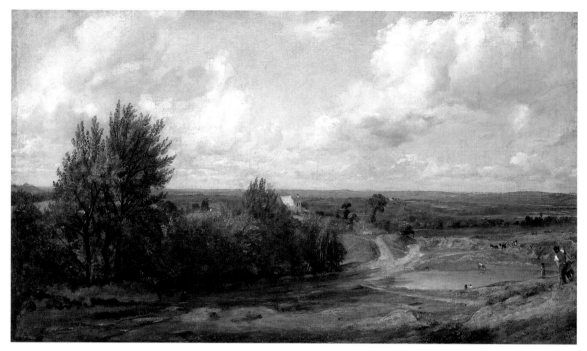

pl.42 'Hampstead Heath with the
House Called "The Salt Box"',
*c.*1819–20, oil on canvas 384 × 668
($15\frac{1}{8}$ × $26\frac{5}{16}$), *Tate Gallery* (cat.no.107)

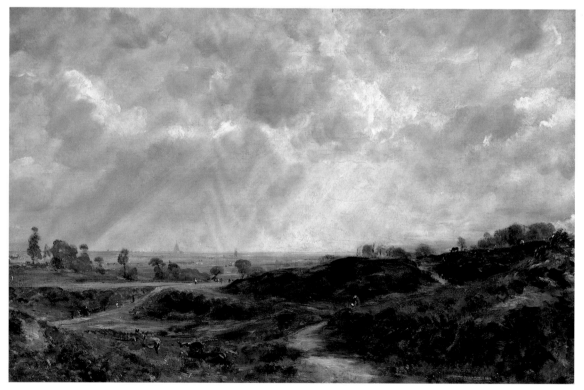

pl.43 'Hampstead Heath with
London in the Distance', *c.*1827, oil
on canvas 323 × 503 ($12\frac{3}{4}$ × $19\frac{13}{16}$), *Mr
and Mrs David Thomson* (cat.no.127)

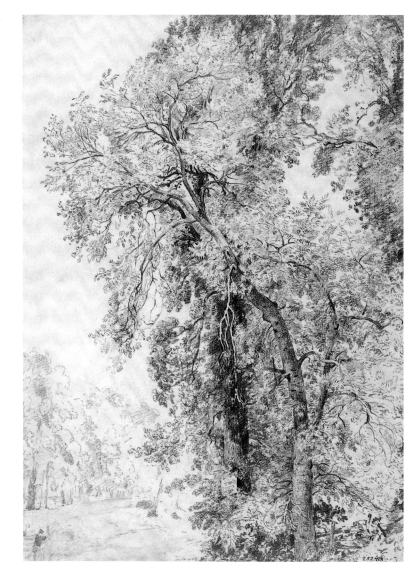

As well as sketching in oils at Hampstead, Constable painted a number of 'finished' works, some of them largely on the spot. Pl.42 shows one of these outdoor pictures, painted soon after his discovery of the heath. Its ponds, sandbanks, donkeys and strolling figures, seen under expansive skies and against distant horizons, became the material for a range of medium-sized pictures executed during the 1820s. Some of Constable's finest tree studies also date from this period. The ash shown in pl.44 was later transplanted in Constable's imagination to Suffolk and used in 'The Valley Farm', his last painting of Willy Lott's house. Most of Constable's Hampstead work was done on the west side of the village but after taking a house in Well Walk in 1827 he started painting the views south-east towards London. Pls.35 and 43 show a study developed in a larger painting that he exhibited in 1830. With its donkeys in the foreground and view of St Paul's in the distance, it epitomises that combination of 'town & country life' that Hampstead made possible for the artist.

Salisbury

Constable first visited Salisbury in 1811, when he stayed at the Palace with his patron Bishop Fisher. It was on this visit, the artist later recalled, that his great friendship with John Fisher, the Bishop's nephew, 'first took so deep a root'. Meeting occasionally but corresponding regularly, Constable came to rely on Fisher for his worldly advice and his humour and for an intellectual stimulus that his own circle was less able to supply. Some of the many practical services Fisher performed – marrying the Constables, hosting them on their honeymoon, buying the first two six-foot Stour pictures – have already been mentioned. In introducing Constable to Salisbury the Fishers, both the Bishop and his nephew, performed one of their most valuable services of all, for it was here and in the countryside round about that the artist found the material for some of his finest works.

pl.45 'Salisbury Cathedral and Leadenhall from the River Avon', 1820, oil on canvas 525 × 770 (20¼ × 30¼), *Trustees of the National Gallery, London* (cat.no.137)

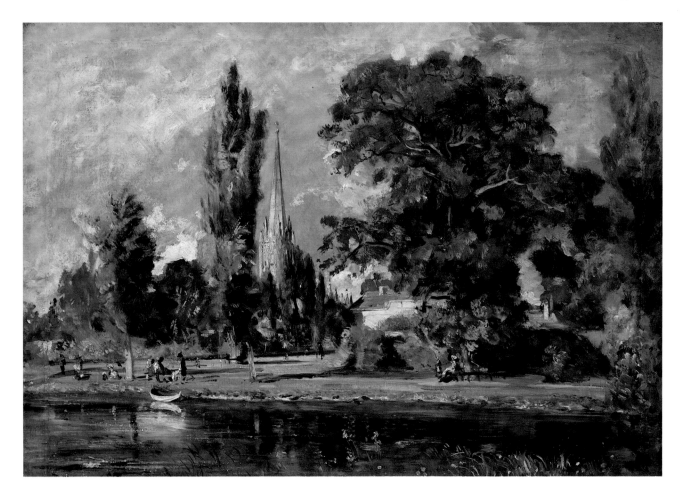

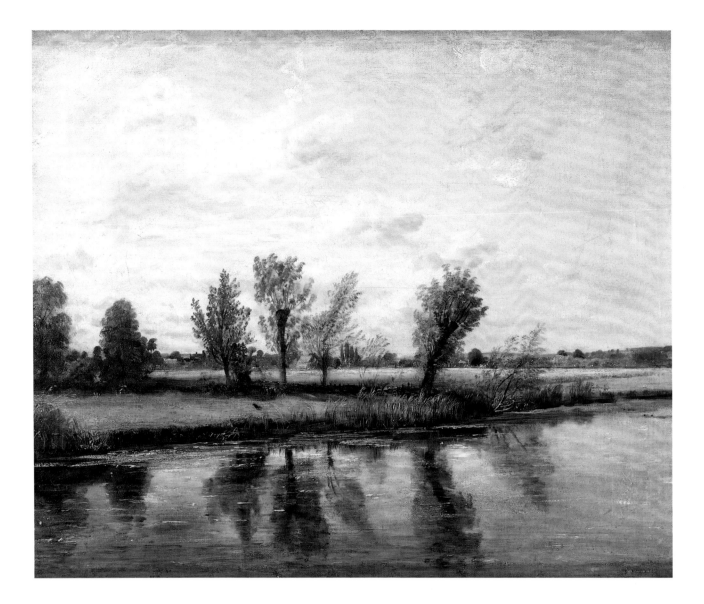

The painting of Fisher's house, Leadenhall, with the cathedral beyond (frontispiece and pl.45) is perhaps the most vibrant of all the outdoor oil sketches Constable made during his second visit to Salisbury in 1820. Late afternoon sunlight floods the scene, casting long shadows across the lawns and throwing into sharp relief the little white boat and the figures by the edge of the Avon. The warmth of the light is suggested by the amount of reddish priming colour that Constable has left visible. 'Watermeadows at Salisbury' (pl.46) is a reciprocal view, looking from Leadenhall across the river. A small finished painting, this is a very different sort of work – silvery in colour, comparatively featureless and with a solitary bird as the only occupant of the scene. Submitted for the Academy exhibition of 1830, it was not recognised as Constable's by the selection committee and was rejected, although – Constable now being an RA – it had no need to be judged at all. But in 1838 it was the only painting for which there was serious competition in the studio sale that followed his death.

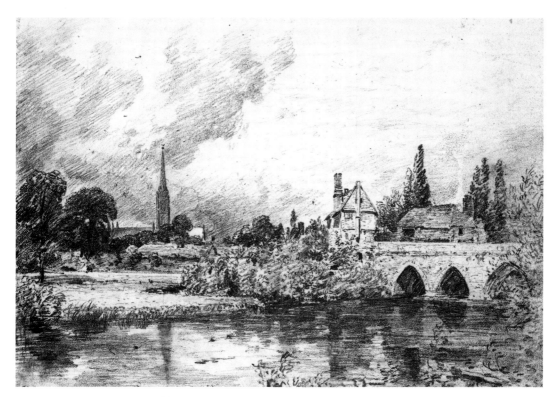

pl.47 'Harnham Bridge', 1820, pencil on
wove paper 155 × 229 (6⅛ × 9), *Trustees of*
the British Museum, London (cat.no.297)

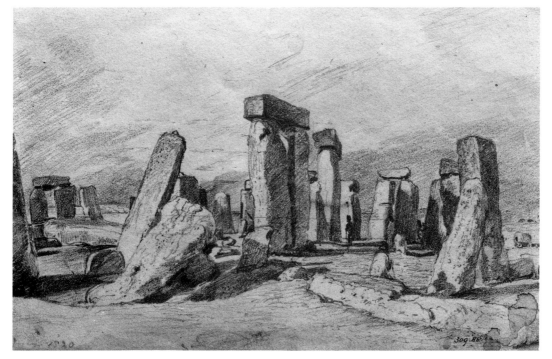

pl.48 'Stonehenge', 1820, pencil on
wove paper 115 × 187 (4½ × 7⅜),
Board of Trustees of the Victoria and
Albert Museum, London (cat.no.291)

Constable painted two grand set-pieces of Salisbury, both taking the cathedral as their focus. The first originated on his 1820 visit, when he made a large sketch of the cathedral seen from the grounds of the Bishop's Palace. Bishop Fisher admired this and eventually commissioned the finished version (pl.49), which Constable exhibited in 1823. At the left the Bishop is shown raising his stick to make some comment about the cathedral to his wife. Framed by a suitably gothic arch of trees, the building soars to the sky, a sky, as it turned out, the Bishop did not much like because of its black clouds (he was to be spared the sight of the still blacker weather in Constable's other large picture of the cathedral, pl.72). On his 1820 visit Constable also explored the outskirts of Salisbury, studying the cathedral from more distant viewpoints (pl.47), and going further afield to Old Sarum and Stonehenge (pl.48), sites that were to inspire large exhibition watercolours in the 1830s, when his awareness of the historical dimension of landscape had become even more acute.

pl.49 'Salisbury Cathedral from the Bishop's Grounds', 1822–3, exh.1823, oil on canvas 876 × 1118 ($34\frac{1}{2}$ × 44), *Board of Trustees of the Victoria and Albert Museum, London* (cat.no.140)

Brighton

By the spring of 1824 it was apparent that Maria Constable needed more than Hampstead air to restore her health: 'we are told we must try the sea', the artist wrote to Fisher. Brighton was chosen and another chapter in Constable's personal and professional life opened. Maria and the children spent much of 1824 there, returning in 1825–6 and 1828. Constable joined them whenever he could and, as at Hampstead, discovered fresh material for his art. At this time Brighton was at the height of its transformation from a quiet fishing village to a second London by the sea. The Royal Pavilion had been exotically refashioned for George IV, new hotels were going up and the Chain Pier, built partly as a berth for the Dieppe ferries, had just opened. Constable tended to shy away from all this, seeking refuge in what he called 'the magnificence of the sea' and studying the everyday life of the beach – the fishing boats and their crews, the larger colliers, all the bustle of what was still very much a workplace. The colliers, seen appropriately as black silhouettes in Constable's celebrated sketch (pl.50), brought coal to within yards of the town centre; beached at high water, they were unloaded as the tide receded. Constable made such sketches, he told Fisher, 'in the lid of my [paint]box on my knees'. The other example shown here

pl.50 'Brighton Beach with Colliers', 1824, oil on paper 149 × 248 (5⅞ × 9¾), *Board of Trustees of the Victoria and Albert Museum, London* (cat.no.147)

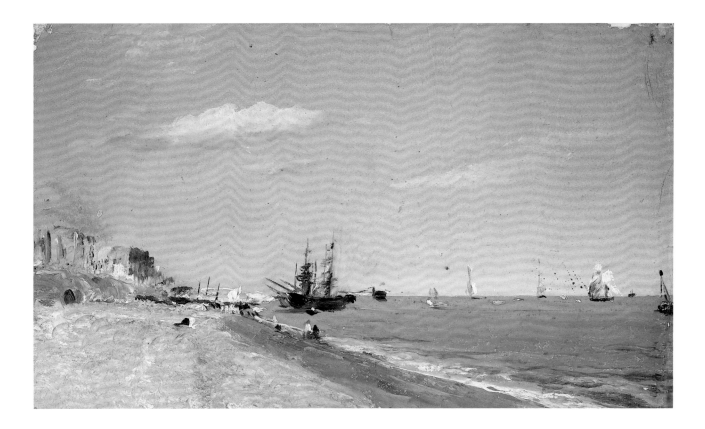

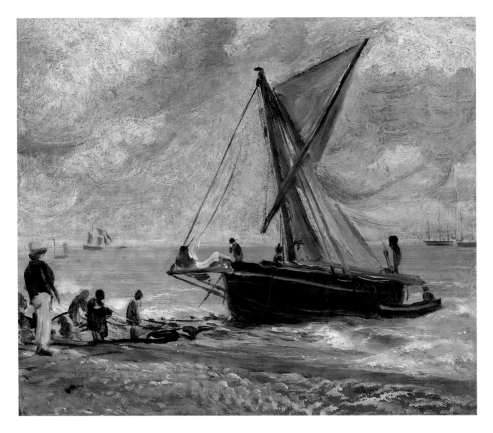

(pl.51), depicting the beaching of a fishing boat, was one of several that Constable referred to when he came to paint his only large canvas of the place, 'Chain Pier, Brighton' (pls.52–3), exhibited in 1827. Despite his declared dislike of the 'unnatural' Marine Parade 'with its trim[m]ed and neat appearance & the dandy jetty or chain pier', he could hardly avoid such a prominent extension to the beach and it proved a useful feature in the articulation of his six-foot picture. The boat-beaching incident seen in the small sketch was taken to pieces and reassembled in various ways in larger sketches. Only the yellow-hatted man survived unaltered, except for his position, in the final picture. Although Fisher admired 'Chain Pier, Brighton' and thought it a 'usefull change of subject', predicting that 'Turner, Calcott and Collins [leading artists in the field] will not like it', the work had a poor reception at the Academy and Constable never found a buyer for it. A few months after reshowing it at the 1828 British Institution exhibition he took Maria, 'sadly ill' with tuberculosis, back to Hampstead after her last stay at Brighton. She died that November and Constable's connection with the place effectively ceased.

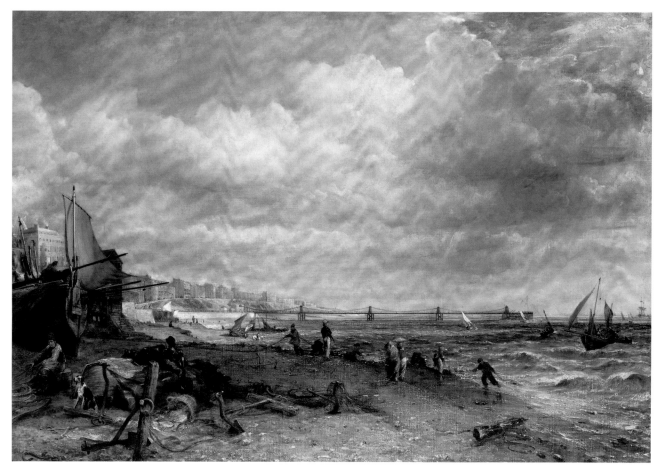

pl.52 'Chain Pier, Brighton', 1826–7,
exh.1827, oil on canvas 1270 × 1830
(50 × 72), *Tate Gallery* (cat.no.156)

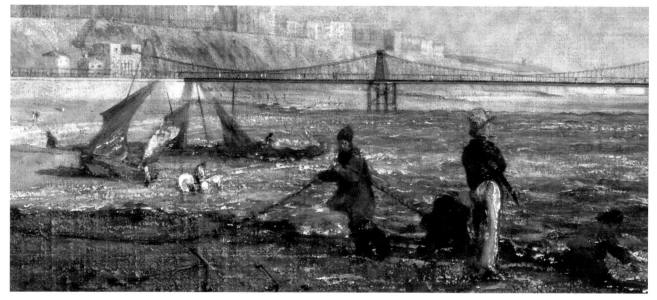

pl.53 'Chain Pier, Brighton' (detail of pl.52)

Later Set-Pieces

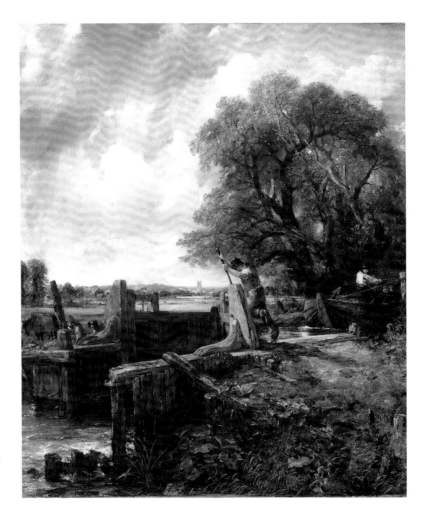

pl.54 'The Lock', 1824, exh.1824, oil on canvas 1422 × 1207 (56 × 47½), *Thyssen-Bornemisza Collection, Lugano, Switzerland* (cat.no.158)

Having exhibited a six-foot Stour painting every year from 1819 to 1822, Constable's work was severely interrupted by illness in the winter of 1822–3 and he had nothing on this scale ready for the 1823 Academy. That year his main exhibit was the Salisbury picture seen in pl.49, just as much a set-piece but on a more modest scale. His large river subjects resumed in 1824 with 'The Lock' (pl.54), a work that placed an even greater emphasis than before on the sort of central figurative incident that he had first established in 'The Hay-Wain'. The opening and closing of lock gates was, so to say, a key moment in the working life of the river and the artist had long been fascinated by it. In his 1824 picture Constable centre-staged the activity he had painted more incidentally around 1811 (pls.17–18) and in his Dedham lock paintings of 1817–20 (pl.55).

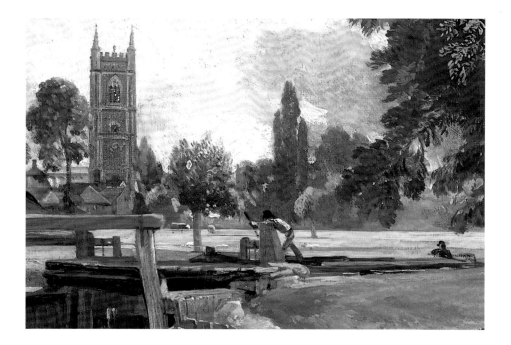

pl.55 'Dedham Lock and Mill'
(detail), ?exh.1818, oil on canvas
700 × 905 (27⁹⁄₁₆ × 35⅝), *Mr and Mrs
David Thomson* (cat.no.94)

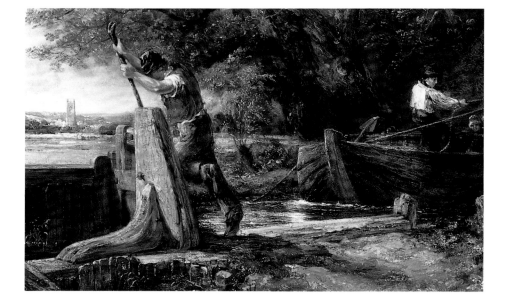

pl.56 'The Lock' (detail of pl.54)

In Constable's several paintings of Dedham lock and mill the figure of the man opening the lock (pl.55) is a small, though beautifully observed, detail, overshadowed by Dedham church. The latter itself becomes a distant detail in the 1824 painting of Flatford lock (pls.54, 56). While wedging the capstan with his knee, the lock-keeper inserts his crowbar to give it a further turn, winding up the chain attached to the 'paddle' and thus releasing the water in the lock. The barge waiting to proceed downstream is held back by a boy who has put a rope round a post on the bank. At the left of the picture the tow-horse enjoys a brief respite from its labours.

Constable's series of six-foot pictures of the Stour reached its climax in 'The Leaping
Horse', shown in 1825 (pls.59–60). The central incident is now more vigorous even
than in 'The Lock'. Like a figure in some heroic battle piece, the boy jumps his horse
over one of the barriers set up on the tow-path to prevent cattle straying. On the barge
that he is towing, a mother cradles her baby as she watches his attempt – the riders
sometimes fell – while a springy, curving willow behind him seems to add to his
momentum. The final composition did not come easily. The leaping horse first
appears in the second of two ink wash drawings (pl.57), riderless and with the willow at
the right. In the full-size oil sketch (pl.58) Constable seems to have tried out the tree in
the position where we see it now in the final work but then to have moved it again to the
right. It still appeared at the right when he first exhibited the 'finished' picture and was
only placed behind the horse later that year; Constable left a stump to mark its former
position. The main group of trees at the left also underwent a major change. In the
1825 exhibit Constable fronted the group seen in the drawing and sketch with the trees
from the right-hand side of his 1817 'Flatford Mill' (pl.31). The tower of Dedham
church was also moved several miles to make an anomalous appearance at the extreme
right. In the interests of picture-making he was now more than ever willing to
disregard niceties of topography. The aspects of nature he was trying to recreate in his
studio did not depend on fidelity of that kind. Though it is the horse that leaps, the
whole picture is about movement, about the animation of nature – 'exhilarating. fresh
– & blowing', Constable described the work to Fisher. And movement is conveyed as
much by his technique of painting as by the subject itself.

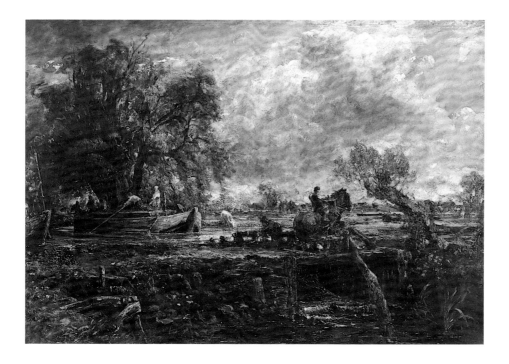

pl.58 'Sketch for "The Leaping
Horse"', 1824–5, oil on canvas
1294 × 1880 (51 × 74), *Board of
Trustees of the Victoria and Albert
Museum, London* (cat.no.161)

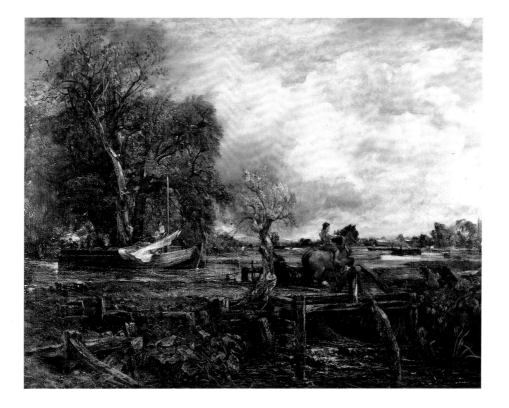

pl.59 'The Leaping Horse', 1825,
exh.1825, oil on canvas 1422 × 1873
(56 × 73¾), *Royal Academy of Arts,
London* (cat.no.162)

pl.60 'The Leaping Horse'
(detail of pl.59)

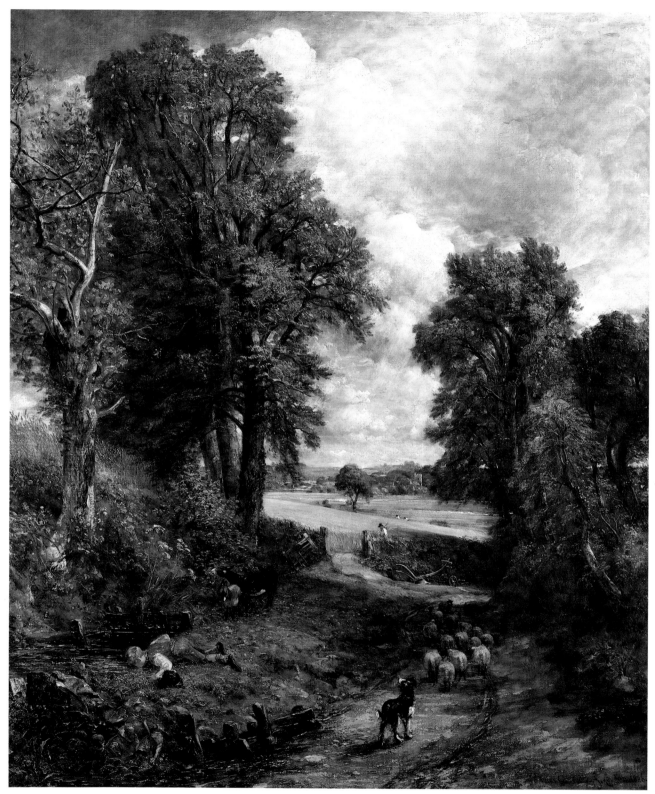

pl.61 'The Cornfield', 1826,
exh.1826, oil on canvas 1430 × 1220
(56¼ × 48), *Trustees of the National
Gallery, London* (cat.no.165)

After 'The Leaping Horse' Constable turned to what he called 'inland' scenery in 'The Cornfield' of 1826 (pl.61). Its basic framework was taken from a large outdoor sketch made in Fen Lane, probably the same summer as the painting of the lane seen in pl.34. A few years before this he had a made a small outdoor sketch that showed a boy drinking from the stream, and even earlier a painting of a wood from which he took the old pollarded oak at the left of the 1826 picture. Further details came from other early studies. Constable's memory of his own previous productions was, clearly, acute; his studio must also have been well organised for him to be able to lay hands on them. Always fascinated by these twisting country routes, Constable produced in 'The Cornfield' his definitive picture of a Suffolk lane, amply suggestive of the slow pace of summer, of its heat (felt by the boy slaking his thirst) and of its sounds – the dog distracted by the noise of the pigeon flying out from the trees at the left. 'The Glebe Farm' (pl.62) is also a lane picture, again with donkeys on the left and a dog entering the scene, but the scale is quite different. As a 'cabinet' picture, intimate in character and very pleasant on the eye, it quickly found a buyer. The church shown is that of Langham, the first living held by Constable's early patron the Bishop of Salisbury. Dr Fisher's death in 1825 appears to have inspired the artist to work up the subject from an early oil sketch.

pl.62 'The Glebe Farm', 1826–7, exh.1827, oil on canvas 465 × 596 (18¼ × 23½), *Detroit Institute of Arts, Gift of Mrs Joseph B. Schlotman* (cat.no.167)

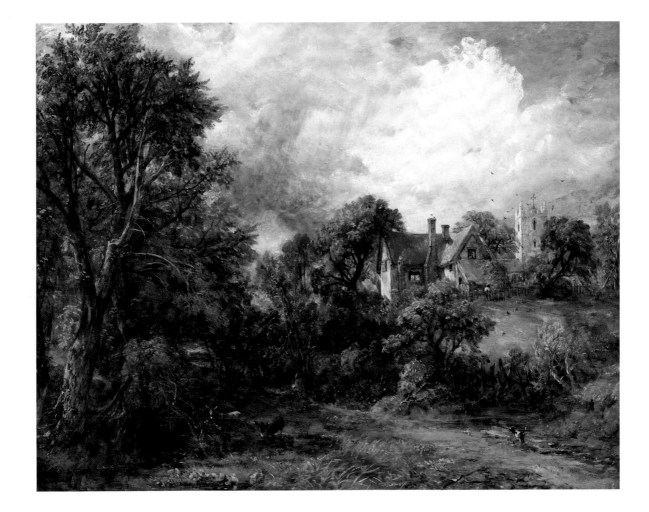

pl.63 'Flatford Old Bridge', 1827, pencil on wove paper 224 × 331 (8$\frac{13}{16}$ × 13$\frac{1}{16}$), *Board of Trustees of the Victoria and Albert Museum, London* (cat.no.316)

pl.64 'Flatford Old Bridge', *c*.1827–33, pencil, pen and brown ink and grey wash on laid paper 179 × 265 (7$\frac{1}{16}$ × 10$\frac{7}{16}$), *Board of Trustees of the Victoria and Albert Museum, London* (cat.no.317)

In 1827 Constable took his two eldest children, aged eight and nine, on their first visit to Flatford. While they fished, he sketched. The drawing shown in pl.63 was made from near the viewpoint adopted for the 1817 'Flatford Mill' (pl.31), a viewpoint the dog has almost taken up again. The later drawing (pl.64), perhaps made with a painting in mind, is a free variation on the subject, with the trees seen at the right of the 1817 picture moved to the nearside of the bridge.

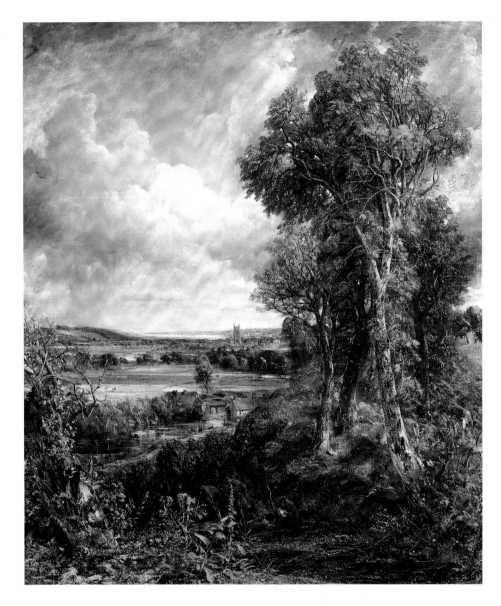

Constable first painted this subject in the little upright study of 1802 seen in pl.2. Subsequently he tried it out in horizontal formats, including a six-foot version which he then abandoned. It was probably the death in 1827 of his friend Sir George Beaumont that inspired him to take up the subject again and in its original vertical form. Since Claude's 'Hagar and the Angel', owned by Beaumont, had been in Constable's mind when he made his 1802 study, the 1828 'Dedham Vale' can be seen both as a private tribute to Beaumont and a celebration of their shared devotion to Claude. Constable's earlier versions suggest that he experienced some difficulty in filling the bottom left corner, occupied by Hagar and the angel in Claude's painting. In this, his final treatment of the theme and his last painting of the Stour valley, he reanimates the corner by introducing an ancient tree stump bursting with new life.

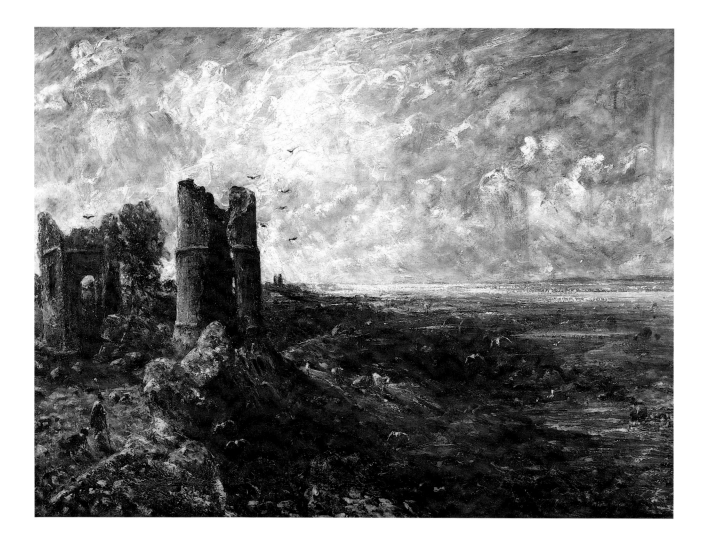

This is the full-size sketch for the painting Constable exhibited in 1829 as 'Hadleigh Castle. The mouth of the Thames – morning, after a stormy night'. The composition originated in a tiny pencil sketch of the castle made in 1814 on his only visit to Hadleigh, near Southend. Constable developed this, as he had with the original ideas for earlier six-foot compositions, by extending the landscape to the right, taking in the distant Kent shore. We do not know why or exactly when he was reminded of Hadleigh but the powerful image of desolation and decay that he created in this sketch undoubtedly matched his mood after Maria's death in November 1828: 'I shall never feel again as I have felt, the face of the World is totally changed to me'. The final painting (Yale Center for British Art) warms the cool tonality of the sketch, defines its often ambiguous forms and tames its savage handling. The striking juxtaposition of solid and void that we see here had already been employed in an early version of Constable's other large Thames subject, 'The Opening of Waterloo Bridge' (see pl.74), in which the spectator is similarly offered a bird's eye view.

pl.66 'Sketch for "Hadleigh Castle"', *c.*1828–9, oil on canvas 1225 × 1674 (48¼ × 65⅞), *Tate Gallery* (cat.no.170)

The 'English Landscape' Mezzotints

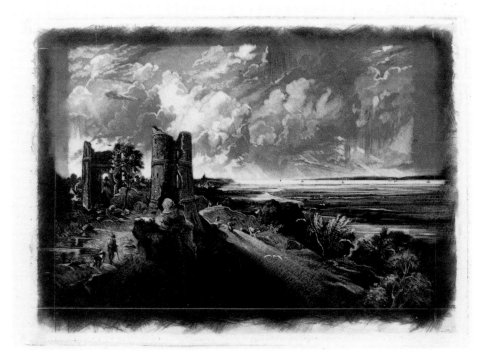

pl.67 John Constable and David Lucas, 'Hadleigh Castle near the Nore' (Progress Proof 'b'), 1832, mezzotint approx. 170 × 240 ($6\frac{11}{16} \times 9\frac{7}{16}$) on laid paper 260 × 355 ($10\frac{1}{4} \times 14$), *Syndics of the Fitzwilliam Museum, Cambridge* (cat.no.202)

Constable was marginally involved with print-making throughout his life but only in his last years did it become of central importance. *Various Subjects of Landscape, Characteristic of English Scenery* (or *English Landscape* for short), the series of twenty-two mezzotints that David Lucas engraved under his close supervision between 1829 and 1832, was a retrospect of his work – in a way, the first Constable exhibition. Paintings of all dates and kinds were chosen for translation into black and white, from small oil sketches of the Suffolk years to large exhibition canvases. The choice was governed by Constable's wish to display the variety of nature, to show how the English landscape looked at different seasons and different times of day, to represent dramatic as well as pastoral scenery. In texts written to accompany the prints Constable tried to explain and justify the views he had long held on the art of landscape. But in offering this survey of his past work, he moved another step ahead of his audience. Mezzotint was the ideal medium for more fully realising the effects of chiaroscuro upon which his paintings had come to depend during the 1820s – those contrasts of light and dark that helped him articulate his large canvases. Working with Lucas on the prints, he decided (and said so on a new title-page) that this was the main purpose of the series, that chiaroscuro was not only an artistic device but a principle of nature itself. The original works were not reproduced in any simple sense but rethought in terms of this

new conviction. With Constable constantly calling, sending instructions, touching and retouching proofs, Lucas achieved remarkable effects, passages of the subtlest tonal gradation as well as bold contrasts. *English Landscape* also gave Constable the opportunity to develop his images in other ways, in particular to work up oil sketches from which he had not made finished paintings. The 'Summer Morning' print was begun from an early sketch of the view of Dedham from the Langham hills (pl.68). From this Lucas produced one of his most successful and beautiful translations (pl.69) but Constable felt that more was needed. Plate 70 shows another impression of the same early state of the print, extensively reworked by Constable to indicate the additions required. The boy was eventually changed into a milkmaid, facing left, then right, then left again. Working through Lucas, Constable treated the prints exactly as he did his canvases.

pl.69 John Constable and David Lucas, 'Summer Morning' (Progress Proof 'b'), 1831, mezzotint 140 × 215 (5½ × 8½') on wove paper 210 × 289 (8¼ × 11⅜), *Syndics of the Fitzwilliam Museum, Cambridge* (cat.no.186)

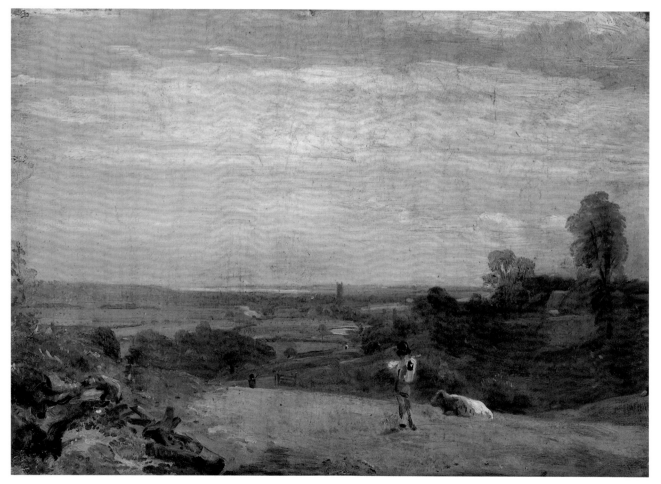

pl.68 'Dedham from Langham', *c*.1812, oil on canvas 216 × 305 (8½ × 12), *Board of Trustees of the Victoria and Albert Museum, London* (cat.no.17)

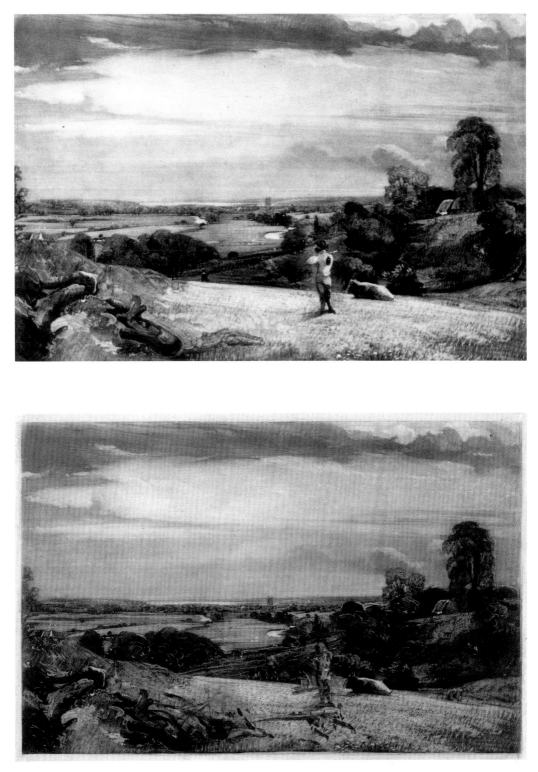

pl.70 John Constable and David Lucas,
'Summer Morning' (Progress Proof 'b',
touched), 1831, mezzotint 140 × 218
($5\frac{1}{2}$ × $8\frac{9}{16}$) on laid paper 162 × 225 ($6\frac{3}{8}$ × $8\frac{7}{8}$),
touched with white body-colour, white
chalk (?), black wash and pencil, *Syndics of the
Fitzwilliam Museum, Cambridge* (cat.no.187)

The 1830s

Although his work with David Lucas took up much of Constable's time in the early 1830s, he nevertheless managed during the same period to paint two of the most ambitious and impressive canvases of his whole career, 'Salisbury Cathedral from the Meadows' (pl.72), shown in 1831, and 'The Opening of Waterloo Bridge' (pl.74), exhibited the following year. Thereafter he showed only two large paintings, 'The Valley Farm' in 1835 and 'The Cenotaph' in 1836. Smaller pictures, drawings and watercolours, including the great 'Stonehenge' watercolour (pl.79), made up the bulk of his final exhibits. A few oil sketches of the middle 1830s, however, suggest that he was planning new large compositions on Suffolk themes (pls.75–8). The colourful and unrestrained character of these works, painted in the studio (there appear to be no outdoor oil sketches after 1829), contrasts strikingly with his last exhibition canvases but can be matched in the wild pencil drawings in his 1835 sketchbook. The variety of his work in the 1830s argues against any neat definition of 'late Constable'. Old subjects, originally studied outdoors, were still being reworked, new ones – imaginary scenes – were conjured up in the studio, while his very last painting, 'Arundel Mill and Castle' (pl.81), was based on fresh visual material, on drawings made on the spot in 1835.

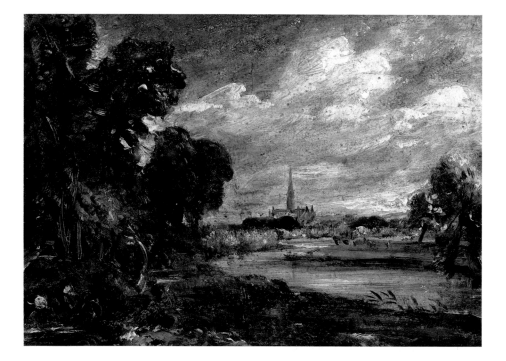

pl.71 'Salisbury Cathedral from the River Nadder', c.1829, oil on paper laid on card 197 × 278 (7$\frac{13}{16}$ × 11), *Private Collection, New York* (cat.no.207)

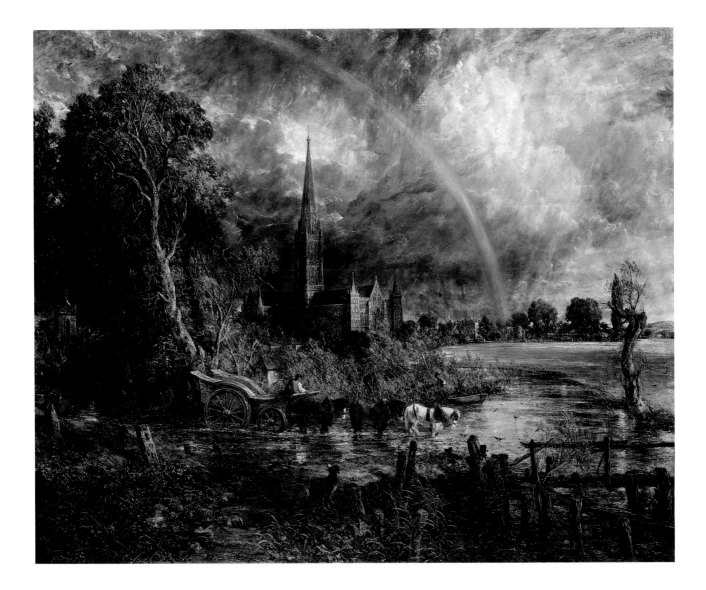

pl.72 'Salisbury Cathedral from the
Meadows', exh.1831, oil on canvas
1518 × 1899 (59¾ × 74¾), *The
Dowager Lady Ashton (on loan to
the National Gallery, London)*
(cat.no.210)

Constable paid his last two visits to Salisbury in July and November 1829. In July he
made a number of drawings of the cathedral seen from across the meadows, or from a
similar distance, and discussed with Fisher the idea of painting a large picture of the
subject. Two small oil sketches – pl.71 shows one of them – soon followed and the
project was taken further in larger sketches painted on the November visit. The final
picture (pl.72) is a majestic display of those effects of chiaroscuro that Constable was
exploring at the same time in his *English Landscape* mezzotints: 'Sudden and abrupt
appearances of light, thunder clouds . . . conflicts of the elements'. As in 'The Hay-
Wain' ten years earlier, a cart fords the water, but this is no longer a placid summer
noon. The same dog who was distracted by a pigeon in 'The Cornfield' (pl.61) now
directs our attention to the storm that rolls around the cathedral, and to the rainbow
that, touching base in Fisher's house, signals its passing.

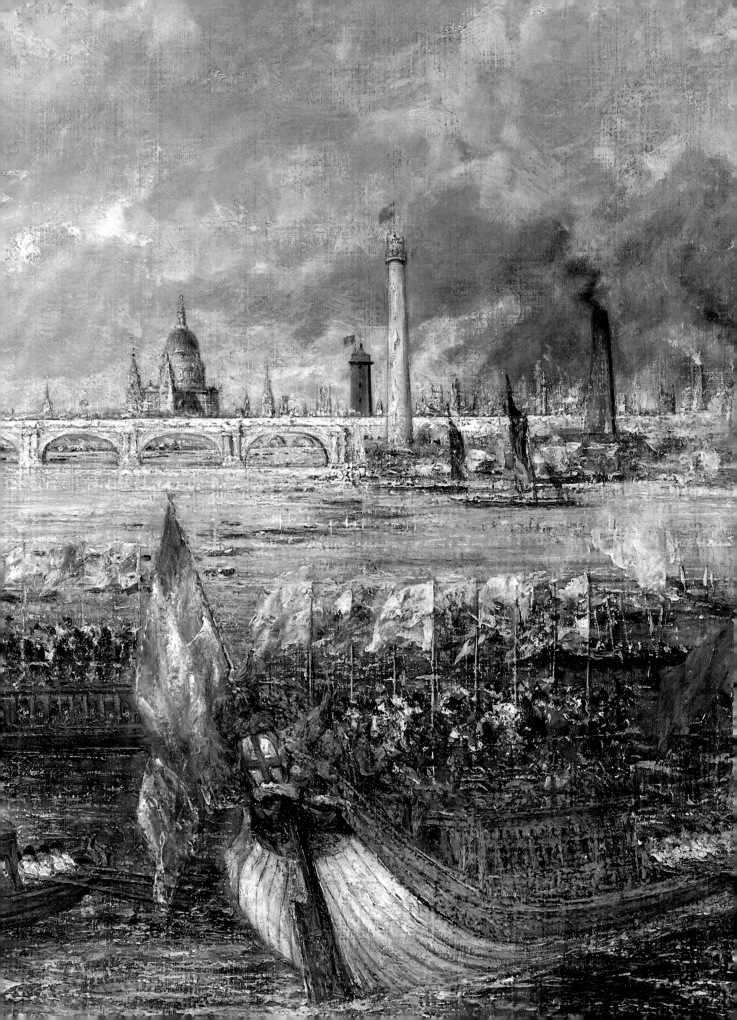

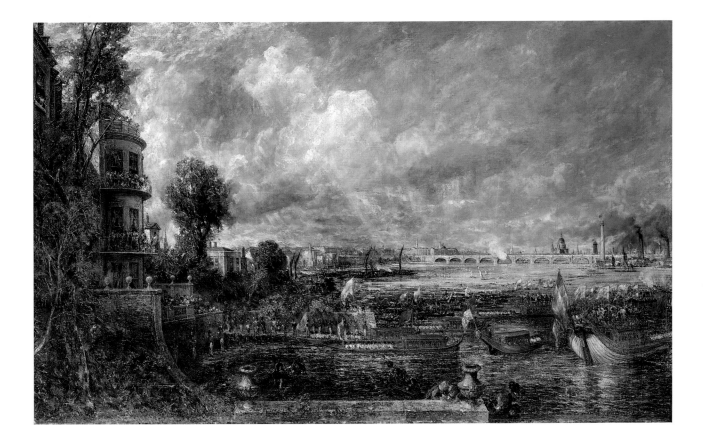

pl.74 'The Opening of Waterloo
Bridge ("Whitehall Stairs, June 18th,
1817")', exh.1832, oil on canvas
1308 × 2180 (51½ × 85⅞), *Tate Gallery*
(cat.no.213)

'The Opening of Waterloo Bridge' was the largest painting that Constable ever
exhibited and the work that took longer than any other of his to reach the Royal
Academy. Drawings made on the day of the opening in 1817 were followed from 1819
onwards by numerous oil sketches and at least one full-size canvas before Constable
felt able in 1832 to submit this final seven-foot picture. Over the years his ideas about
how to treat the subject changed. Instead of closely focusing on the scene at the foot of
Whitehall Stairs, with the Prince Regent about to embark for the short river journey to
open the bridge, Constable gradually expanded his composition by taking a higher
and more distant view of the whole scene. The royal embarkation receded into the
middle-distance as he added more buildings and trees at the left and, in the fore-
ground, a parapet against which two boys lean, oblivious to the ceremonies. Lines of
soldiers, colourful barges and flags are finally enclosed and framed by the natural
splendour of trees, water and sky. Constable's description of himself in February 1832
as 'dashing away at the great London' is borne out by the picture's lively and varied
surface, areas of exposed brown priming contrasting with vigorous strokes and stabs
of the boldest reds and greens.

pl.73 'The Opening of Waterloo
Bridge ("Whitehall Stairs, June 18th,
1817")' (detail of pl.74)

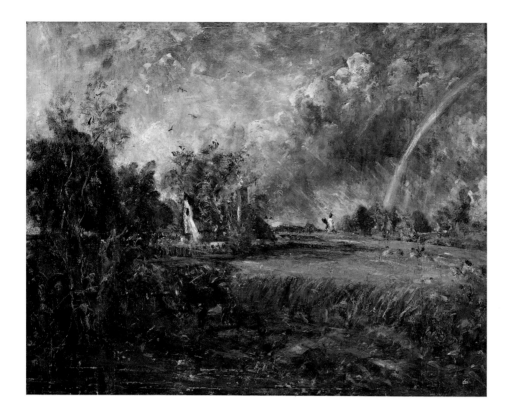

pl.75 'A Cottage at East Bergholt',
1830s, oil on canvas 876 × 1118
(34½ × 44), *National Museums and
Galleries on Merseyside (Lady Lever
Art Gallery)* (cat.no.217)

The three paintings shown in pls.75–8 are studio sketches in which Constable appears
to have been inventing new subjects loosely based on earlier works. By the mid-1830s
fresh ideas for six-foot pictures came less easily to him, as he explained to a friend:
'The difficulty is to find a subject fit for the largest of my sizes. I will talk to you about
one, either a canal or a rural affair, or a wood, or a harvest scene – which, I know not'.
The two 'Farmhouse' sketches are distantly derived from an image of Willy Lott's
house but they no longer have any topographical reference. The larger of the two
(pls.77–8), with its exuberant handling and freely invented subject matter, represents
the furthest extreme of Constable's late manner. Its size suggests that it may have been
intended as a half-scale study for a six-foot picture, but Constable never took this
brilliant sketch further. Perhaps, after all, he found that he needed a more factual basis
to make a credible image on the larger size. The 'Cottage' sketch (pl.75) seems to be
based on memories or other images of East Bergholt Common, with the donkeys taken
from a much earlier painting of a different cottage that Constable finished and
exhibited in 1833. He frequently extended his canvases while working on them; this
one was enlarged by a foot or so at the right, no doubt to accommodate the rainbow.
One wonders whether Constable ever recalled during these years his endeavour at
Bergholt in 1802 'to get a pure and unaffected representation of the scenes that may
employ me'. These late works are, perhaps, no less 'natural' but it is a very different
nature that Constable now reveals to us.

pl.76 'A Farmhouse near the Water's Edge', ?*c*.1834, oil on canvas 254 × 349 (10 × 13¾), *Board of Trustees of the Victoria and Albert Museum, London* (cat.no.214)

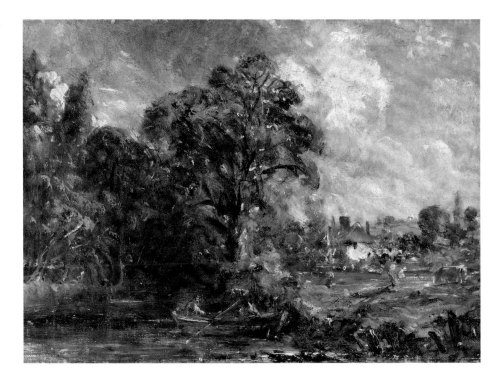

pl.77 'A Farmhouse near the Water's Edge ("On the Stour")', ?*c*.1834, oil on canvas 620 × 790 (24⅜ × 31⅛), *The Phillips Collection, Washington DC* (cat.no.215)

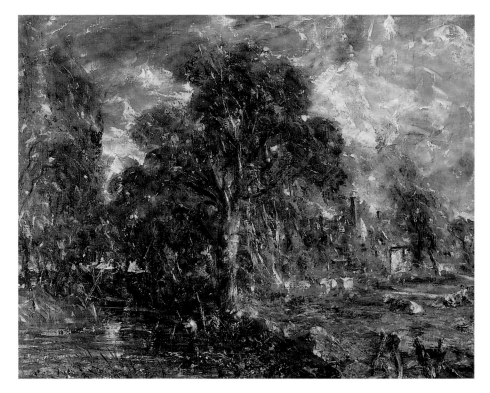

'The mysterious monument of Stonehenge,' runs Constable's text for this work,
'standing remote on a bare and boundless heath, as much unconnected with the events
of past ages as it is with the uses of the present, carries you back beyond all historical
records into the obscurity of a totally unknown period'. The drawing made on his visit
to Stonehenge in 1820 (pl.48) already includes the figure of a seated man contemplat-
ing his own shadow as it falls on one of the stones – a variation on a churchyard image
often used by Constable. The 1836 watercolour and its text invite us to consider longer
time spans than that of human life. Stonehenge, no more the sunlit, almost intimate
stone circle Constable drew in 1820, stands dramatically isolated on the 'boundless
heath' as the elements rage around it. Degrees of transience and permanence are
everywhere suggested: the stones survive but the civilisation that erected them is lost
in obscurity; the weather is rapidly changing but will continue for ever; men and
animals come and go. While a wagon rolls over the plain at the right, at the bottom left
a frightened hare (itself painted on a separately applied scrap of paper) scuttles away
from this apocalyptic scene.

pl.79 'Stonehenge', 1835, exh.1836,
pencil and watercolour on wove paper
387 × 591 (15¼ × 23⅝₁₆), *Board of
Trustees of the Victoria and Albert
Museum, London* (cat.no.345)

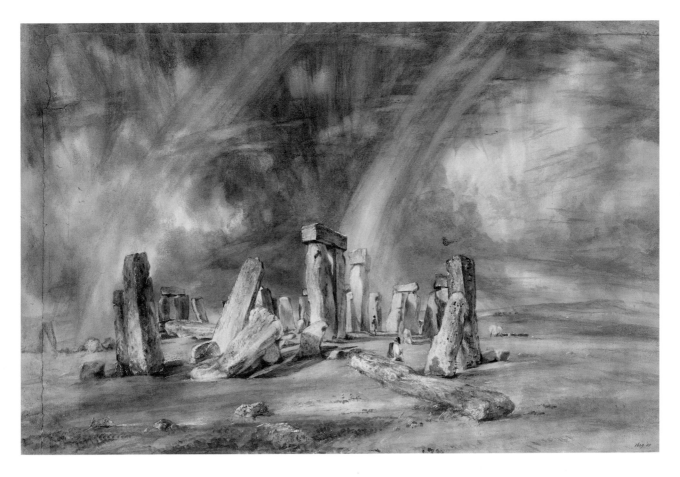

Although much of Constable's late work was a rethinking of earlier themes, he was able to add to his stock of material when a new friend – an unrelated namesake, George Constable of Arundel – introduced him to the West Sussex countryside. Staying with him in 1834 and 1835 Constable explored the Arun and Rother valleys, visited Petworth and Cowdray and part of the coast. At Arundel he found the subject for a new painting, the mill and castle in their setting of woods and precipices. A masterful drawing made in 1835 (pl.80) was the basis for what was to be his last painting (pl.81). Arundel was new to Constable but it brought back memories of other watery places, Flatford in particular. There are echoes here of Willy Lott's house, especially as depicted in the 1835 'Valley Farm', while the young anglers are familiar from his many paintings of the banks of the Stour. Constable was working on the nearly finished 'Arundel' shortly before he died during the night of 31 March–1 April 1837. His death was unexpected and C.R. Leslie, his friend and first biographer, was not surprised to see Constable's messenger at his door next morning: 'I ran down expecting one of

pl.80 'Arundel Mill and Castle', 1835, pencil on wove paper 219 × 281 ($8\frac{5}{8} \times 11\frac{1}{16}$), *Board of Trustees of the Victoria and Albert Museum, London* (cat.no.338)

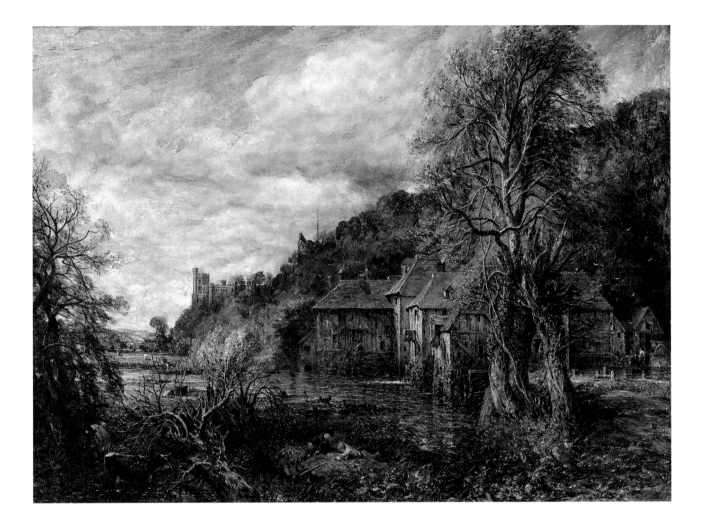

Constable's amusing notes, or a message from him; but the message was from his children, and to tell me that he had died suddenly the night before. My wife and I were in Charlotte Street as soon as possible. I went up to his bedroom, where he lay, looking as if in tranquil sleep; his watch, which his hand had so lately wound up, ticking on a table by his side, on which also lay a book he had been reading scarcely an hour before his death. He had died as he lived, surrounded by art, for the walls of the little attic were covered with engravings, and his feet nearly touched a print of the beautiful moonlight by Rubens, belonging to Mr. Rogers'. 'Surrounded by art', yet – Leslie continued – 'Among all the landscape painters, ancient and modern, no one carries me so entirely to nature . . . I have never looked at a tree or the sky without being reminded of him'.

John Constable: A Brief Chronology

1776
Born at East Bergholt, Suffolk, fourth child of Ann and Golding Constable, corn and coal merchant and farmer

c.1792
After schooling in Essex and at Lavenham and Dedham, begins works for his father

1795
Is introduced to Sir George Beaumont, collector, painter and an influential figure in the London art world

1796
Meets J.T. Smith, John Cranch and other artists; this year or the next meets Dr Fisher, later Bishop of Salisbury, who, like Beaumont, is to play an important role in his career

1799
His parents consent to him studying art; after obtaining an introduction to Joseph Farington, another important early mentor, enters Royal Academy Schools as a probationary student

1801
A long visit to Staffordshire and Derbyshire, staying with relations

1802
Exhibits at RA for the first time; disappointed by what he sees in the exhibition, resolves to paint directly from nature in Suffolk

1805–6
Much time devoted to drawing, especially on a tour of the Lake District in 1806

1808–10
Develops a new oil sketching style

1809
Declares his love for Maria Bicknell, daughter of Charles Bicknell (solicitor to the Regent and the Admiralty) and grand-daughter of the rector of East Bergholt

1811
Exhibits 'Dedham Vale: Morning', his first major picture of his native scenery; stays at Salisbury with the Bishop and his wife;

meets the Bishop's nephew, John Fisher (later Archdeacon of Berkshire), who becomes his closest friend

1814
Begins trying to paint finished pictures on the spot in Suffolk

1815
Death of his mother

1816
Death of his father; marries Maria Bicknell; most of their honeymoon spent at Osmington, Dorset with John and Mary Fisher

1817
The Constables take a house in Keppel Street, Bloomsbury (later moving to Charlotte Street); they holiday together for the last time in Suffolk; birth of John Charles, the first of their seven children

1819
Exhibits 'The White Horse', the first of a series of six-foot canvases of river Stour subjects painted entirely in the studio; rents a house at Hampstead this summer and succeeding ones; elected Associate of Royal Academy; friendship with C.R. Leslie (his future biographer) formed about this time

1820
Stays with John Fisher at Salisbury

1821
With Fisher in Berkshire and later in the year at Salisbury

1823
Visits Salisbury again, and Gillingham, Dorset; stays with Sir George Beaumont at Coleorton Hall, Leicestershire

1824
'The Hay-Wain' and other pictures shown at Paris Salon are enthusiastically received by young French artists; takes Maria to Brighton on the first of several visits, hoping to cure her failing health

1825
Exhibits the last of the six-foot Stour pictures, 'The Leaping Horse'

1826
For his largest paintings, now turns to 'inland' scenery ('The Cornfield' shown this year) and later to subjects outside Suffolk

1827
The Constables move to Well Walk, Hampstead and let part of their Charlotte Street house; the artist takes his two eldest children to Flatford on holiday

1828
Maria gives birth to their seventh and last child, Lionel; after their final visit to Brighton she dies at Hampstead of tuberculosis

1829
Elected a Royal Academician; stays with the Fishers at Salisbury in July and November; begins work with David Lucas on the *English Landscape* mezzotints

1830–2
Publication of first edition of *English Landscape*

1832
Death of John Fisher

1833
Visits Folkestone, where his two eldest sons are at school

1833–6
Lectures on landscape painting at Hampstead, the Royal Institution and Worcester

1834
Stays at Arundel with a new friend (though no relation), George Constable; visits Petworth and other places in West Sussex

1835
Again at Arundel; visits Worcester to lecture

1837
Dies at his Charlotte Street house; is buried alongside Maria in the churchyard of St John's, Hampstead

Further Reading

Leslie Parris and Ian Fleming-Williams, *Constable*, Tate Gallery 1991 (catalogue of the exhibition)

CONSTABLE'S WRITINGS AND OTHER CONTEMPORARY DOCUMENTS

R.B. Beckett (ed.), *John Constable's Correspondence*, 6 vols., 1962–8, *John Constable's Discourses*, 1970; L. Parris, C. Shields, I. Fleming-Williams, *John Constable: Further Documents and Correspondence*, 1975; J. Ivy, *Constable and the Critics 1802–1837*, 1991

BIOGRAPHIES AND GENERAL SURVEYS OF CONSTABLE'S WORK

C.R. Leslie, *Memoirs of the Life of John Constable, Esq. R.A.*, 1843, 2nd ed. 1845 (most recent edition by J. Mayne, 1951 and subsequent printings); G. Reynolds, *Constable: The Natural Painter*, 1965 and later editions; M. Rosenthal, *Constable: The Painter and his Landscape*, 1983, *Constable*, 1987; M. Cormack, *Constable*, 1986

SPECIALISED STUDIES

I. Fleming-Williams and L. Parris, *The Discovery of Constable*, 1984; I. Fleming-Williams, *Constable and his Drawings*, 1990

CATALOGUES OF CONSTABLE'S WORK

G. Reynolds, *Victoria and Albert Museum: Catalogue of the Constable Collection*, 1960, 2nd ed. 1973; L. Parris, I. Fleming-Williams, C. Shields, *Constable: Paintings, Watercolours & Drawings* (catalogue of Tate Gallery bicentenary exhibition), 1976; R. Hoozee, *L'opera completa di Constable*, 1979; L. Parris, *The Tate Gallery Constable Collection*, 1981; G. Reynolds, *The Later Paintings and Drawings of John Constable*, 1984

The Friends of the Tate Gallery

BECOME A FRIEND AND ENJOY:

** Free entrance to all Tate Gallery exhibitions with a guest
** Invitations to exhibition Previews
** 10 per cent discount on current exhibition catalogues and in the Tate Gallery Shop
** Special openings of the Gallery with lectures
** *Preview* magazine mailed three times a year
** *Friends Events* mailed three times a year
** Friends Curator who attends special events

Friends may bring two guests and children under sixteen to SPECIAL OPENINGS

Friends' subscriptions help to purchase works of art to add to the National Collection of British and Modern Art in the Tate Gallery. Works acquired include 'The Snail' by Henri Matisse, 'Mr and Mrs Clark and Percy' by David Hockney and Pablo Picasso's 'Weeping Woman'.

PATRONS

The Patrons of New Art promote a lively and informed interest in comtemporary visual art. They participate in the Tate Gallery's acquisitions of contemporary art through the purchase of works by artists such as Anselm Kiefer, Julian Opie, Sean Scully and Lothar Baumgarten. The works are chosen by a committee of Patrons in consultation with the Director of the Tate Gallery and are offered to the Trustees as gifts from the Patrons of New Art.

The Patrons of New Art are associated with the Turner Prize, one of the most prestigious awards for the visual arts. Prize winners include Malcolm Morley, Gilbert and George, Howard Hodgkin and Richard Long.

The Patrons of British Art have a particular interest in British painting from the Elizabethan period through to the twentieth century. Their donations are used to make important acquisitions for the Tate Gallery, for example, 'Equestrian Portrait of George II' by Joseph Highmore and 'A Classical City' by John Varley.

The Patrons of New Art and the Patrons of British Art are automatically members of the Friends of the Tate Gallery.

For further information on the Friends of the Tate Gallery please telephone 071–834 2742 or 071–821 1313 or write to The Friends of the Tate Gallery, Tate Gallery, Millbank, London SW1P 4RG